Salve Regina

The Story of Mary

Cover: Raphael, *The Sistine Madonna* (detail), 1513.
Gemäldegalerie, Dresden.

JACQUES DUQUESNE

Salve Regina
The Story of Mary

Flammarion

How beautiful you are, my beloved, how beautiful you are!
Your eyes are doves (Song 1:15).
As a lily among the thistles,
so is my beloved among girls (Song 2:2).
Show me your face,
let me hear your voice;
for your voice is sweet
and your face is lovely (Song 2:14).

Though not addressed to Mary, these verses from Solomon's magnificent biblical poem, the Song of Songs, may well have inspired and guided many of those who, over the centuries, have sought to capture her likeness.

How could she be portrayed as anything but beautiful, whether with joy at the birth of her son or in the tortured sorrow of seeing him suffer on the Cross?

Our ideas of beauty and indeed the roles ascribed to Christ's mother—mediator, intercessor at the Last Judgment, or queen—may change with times and cultures, but paintings and statues always portray her as mild and beautiful. Without Mary, the history of art would have been quite different, since her images surround us. There are three reasons for this. The first is theological: Christianity is the only religion claiming that God became man and that a man was God incarnate—with a bodily form. This "Incarnation" was made possible through Mary. Jesus "was born of woman," (Gal. 4:4) wrote Paul, dwelling no further on matters of the birth. The phrase "born of woman," says it all. Images of Mary rocking the Christ Child, and, moreover, nursing him at her breast ("Maria Lactans" in vogue since the sixteenth century) confirm that he is indeed a flesh-and-blood human being and that the woman who nurtured, fed, and raised him would reap infinite rewards in heaven.

The second reason that Mary has so influenced the history of art is linked to the idea of beauty. Judaism, which gave rise to Christianity, prohibited any graven image of God. Christians apparently followed this teaching for two centuries. But belief in the Incarnation— along with Greek influence—changed things. Evangelized by Christian missionaries, the

Greeks considered beauty as a reflection of divinity. "A thing of beauty is good; there is no goodness without beauty," claimed the Greek poet Theognis as early as the sixth century B.C.E. Devotion to the Virgin Mary went hand in hand with the revalorization of beauty, which had sometimes been criticized in the early centuries of Christianity.

The third reason that Mary is so present in our art is that, being a real woman and mother, she knew both pleasure and pain, worried like any mother, and was tied to her home and daily chores like any other woman. She was close—indeed very close—to all human beings.

This explains why artists have been so taken with Mary. Even more than in written accounts, art reveals how devotion to Mary took shape and evolved. Yet art not only records and depicts: it acts upon, influences, and provides a backdrop to both individual private prayer and organized liturgical services. The images brought together and commented upon in this book are, of course, meant to be enjoyed and admired. But they can also help us to understand who Mary was and how she became the most beloved woman in the world. And finally, for many readers, they may also serve as an aid to meditation and prayer.

Yet, there is a troubling paradox: Mary is virtually absent from the Gospels. And when mention is made of her, she is sometimes simply called the "mother" of Christ or the "spouse" of Joseph. Beyond the accounts of the Nativity in Matthew and Luke, hardly any reference is made to Mary, and nothing is said about her background, her parents, or her life.

Nevertheless, the Catholic Church celebrates the feast days of Saint Anna, her mother, and Saint Joachim, her father. Various paintings and a multitude of prints and miniatures depict Mary as a child or show her betrothal to Joseph under the guidance of the Jewish high priest. Most are based on a text known as the Protevangelium of James (or Infancy Gospel of James) dating to the mid-second century. This text enjoyed a wide readership: more than one hundred fifty Greek manuscripts have been discovered and versions also exist in other ancient languages (in particular, Latin, Armenian, Coptic, Arabic, and even Old Irish). It forms part of the liturgy of the Eastern churches. In the sixth century, the Roman Catholic pope, Gelasius, condemned the text as issuing from heretical and schismatic sources, but this did not stop it from spreading. Indeed, it was to reemerge later in an edited version entitled the Gospel of Pseudo-Matthew.

Both of these works were to have a considerable influence on popular imagery and paintings by great artists. To give but one example, they set the birth of Jesus in a cave,

whereas Luke, an Evangelist recognized by the Church, speaks of a stable, perhaps a kind of shed: *katalyma* in Greek, the language in which the Gospel was written. It was also the Gospel of Pseudo-Matthew (apparently dating to the seventh century) that introduced the ox and the ass that "kneeled and adored Him." The author adds: "Then was fulfilled that which was said by Isaiah the prophet, saying: 'The ox knoweth his owner, and the ass his master's crib'" (Pseudo-Matt. 14:1). Actually, when Isaiah spoke of the ox and ass, it was in a completely different context. Yet this quotation from Pseudo-Matthew illustrates the intentions of the authors of these works: addressing a readership hungry for spectacular elements, they wanted to show that the coming of Jesus was indeed decreed in the Old Testament.

While modern man is not averse to spectacular elements, he also appreciates historical accuracy. But what is known historically? To begin with, Mary (as many images have tended to forget) was a young Jewish woman and as such would have had dark hair: two clusters of black grapes framing a smile. She was young, still a young girl, when betrothed to Joseph. At the time, there were two stages to marriage: first a mutual agreement, followed (after a variable time period) by the young woman taking up residence in her spouse's home—the fiancée already being considered his wife. The couple lived in Nazareth, a small village in Galilee, an area that was also home to various heathen populations. Phoenicians, Syrians, Arabs, and Greeks had settled there to work the land and, particularly, for trade. The olives of the region were highly prized and their oil was exported throughout the Mediterranean. Pressing took place in a new city very close to Nazareth called Sephoris that was under construction at the time. It was the capital of Herod Antipas, a son of Herod the Great. This accounted for the influx of immigrant laborers. Yet unemployment was not unknown here, as the Gospels point out. And it was a world of poverty. Cramped together, the small houses were made of mud bricks and had roof terraces made of woven branches set on rafters and covered with clay—these served as sleeping areas in summer.

Inside the house was the woman's—and therefore Mary's—realm. A careful reading of the way that domestic chores feature in the parables of Jesus suggests that his mother was likely to have patched clothes, ground flour for bread using a hand mill, and swept the beaten earth floor. Joseph, a carpenter, was probably an important figure in the village. Yet Mary clearly did not inhabit a city of silent palaces, as the Renaissance painters would have us believe. Her world was rather a kind of shantytown of narrow alleyways, thronged with a rowdy bunch of cantankerous and playful street urchins.

Surrounded by immigrants, the true Galileans adopted a stiff stance in matters of identity and the customs, rites, and rules of their religion. Everything suggests that Jesus would thus have received a very strict and serious religious education. It is therefore quite easy to imagine the problem facing Mary, the questions she may have asked herself, and the heartbreak she may have experienced when her son challenged some of the principles and precepts of Judaism. Yet she managed to overcome her doubts and wariness and stood by her son until death, through the humiliating Crucifixion that followed a night of torture.

In the Acts of the Apostles, a text largely attributed to Luke that relates the lives of the first Christians, Mary is mentioned along with "some women" and the "brothers" of Jesus, who had come together after his death to pray in a place called the "upper room" (Acts 1:13–14). This was the beginning of the church. And "Mary the mother of Jesus" (Acts 1:14) was there as usual. She had therefore been present during the full course of the Life of Jesus—a life that would shake up world history. The Gospels make no further comment about Mary—and why should they?

Her mission was over. As the French Catholic author Georges Bernanos put it, Mary had never encountered "triumph or miracle. Her son did not allow human glory to brush against her, even from the very tip of its great savage wing. No one lived, suffered, or died with such simplicity in such deep unawareness of her dignity." It is such dignity that raises so high this mother—in her lifetime called by the Hebrew name of Myriam—a woman with work-worn hands, tired eyes, and a back that ached from having borne too heavy a burden. She was a woman who never lost hope in faith.

Francisco de Zurbarán, *Childhood of the Virgin* (detail), 1650. Hermitage Museum, Saint Petersburg.

Childhood

What was she like? Which games did she play? How did her parents teach her about God, the Law, and the prophets? We would all like to know more about Mary's childhood. Yet the canonical Gospels (accepted by most Christian churches) remain silent on this matter, not even mentioning the names of her parents. The apocryphal Gospels, on the other hand, contain a wealth of detail of doubtful historicity. They do show, however, that as early as the second century, people in their everyday devotion, particularly in the East, claimed Mary as their own. Over the centuries, artists have continued that tradition.

I ANNA AND JOACHIM

If we are to believe the apocryphal Gospels, Mary's parents were called Anna and Joachim and the Catholic Church recognizes them as saints. Joachim was very wealthy and generous, and owned a large number of flocks. He kept for himself only a third of his income; giving a third to "the orphans, the widows, the strangers, and the poor" (Pseudo-Matt. 1:1) and the remainder to the priests. According to the same source, he was twenty years old when he married Anna, a descendant of the line of David. Yet twenty years later, they were still childless. For Jews, barrenness was a catastrophe, almost the sign of a curse, to the extent that a priest called Ruben (which in Hebrew means "he has witnessed my distress") drove Joachim out from the Temple, saying that among lawful men "God has not blessed thee so as to give thee seed in Israel" (Pseudo-Matt. 2:1). If Joachim was childless, he was not "lawful."

However, the men who forced Joachim to flee had apparently forgotten the story of Abraham and Sarah who, according to Holy Scriptures, were almost one hundred years old when God blessed them with a son, Isaac. Three travelers brought Abraham the good news. In his painting on the facing page, Flemish painter Jan Provost has shown only one of them, giving him the appearance of an angel, which was quite common in the sixteenth century and is in keeping with the character of the episode in Genesis. However, he had no qualms about placing Abraham and Sarah at the entrance of a marble palace, while these nomads would have lived in a tent. Interestingly, no writings mention the "Golden Gate" where Giotto sets the meeting of Anna and Joachim, already encircled with halos like Christian saints (pp. 14–15). This was apparently one of the many gates to the fortified city of Jerusalem.

Jan Provost, *Abraham, Sarah, and the Angel* (detail), 1515. Musée du Louvre, Paris.
Following pages: Giotto, *The Meeting at the Golden Gate*, 1304–06. Cappella Scrovegni (Arena Chapel), Padua.

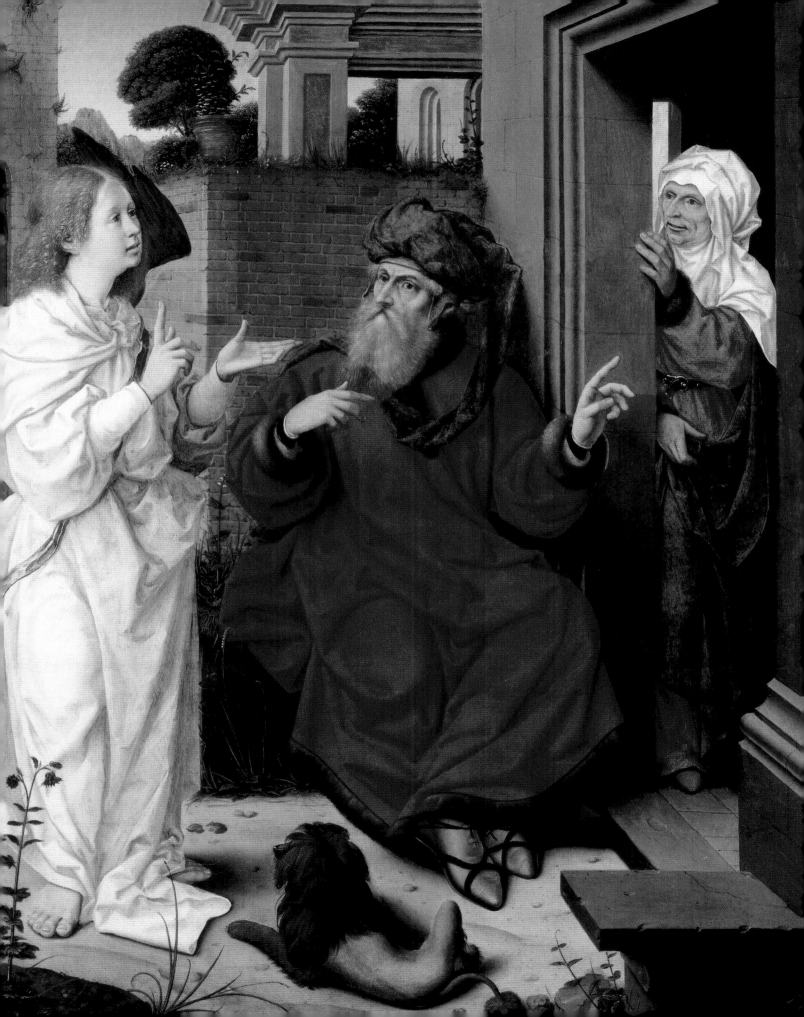

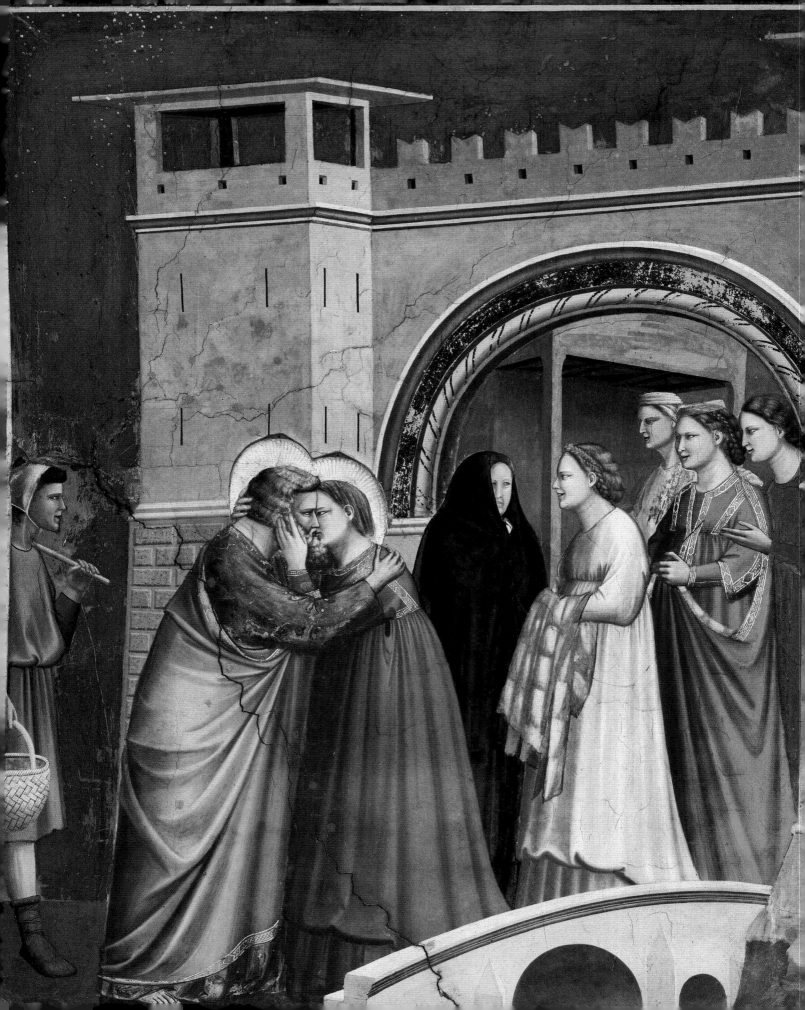

Had Joachim lost all hope? This is the version given in the apocryphal text known as the Gospel of Pseudo-Matthew. The Protevangelium of James, on the other hand, describes how Joachim spent forty days in the desert to pray to God for a child, as he recalled the favor granted to Abraham. In the Bible, the number forty is often associated with a period of hardship: the Great Flood lasted for forty days. Here, it may perhaps refer to the forty days that Jesus spent in the desert before he began his life in the public eye. In any event, the painter Giotto portrayed the announcement to Joachim as foreshadowing the later announcement to Joseph: the angel appeared to him in a dream, as was the case for Joseph, whereas according to the texts of the Protevangelium and Pseudo-Matthew—the only ones to record this episode—he was wide awake, tending his flocks. And he was delighted, of course.

As for Anna, she had gone down into her garden deeply distressed. James describes how she gazed at a nest of sparrows hidden in a laurel tree. "I am not likened unto the beasts of the earth, for even the beasts of the earth are fruitful before thee, O Lord. Woe unto me, unto what am I likened?" (Prot. James 3:2). But the angel appeared to her, saying that she would conceive and bear a child and that her "seed shall be spoken of in the whole world" (Prot. James 4:1). This mid-second-century text was easily accurate in its "prediction," as the name of Jesus was already well known in the Roman world, being cited, for example, by the writers Tacitus and Suetonius. For both Anna and Joachim, in any event, this spelled happiness. When Joachim returned with his flocks, Anna hung upon his neck. She had promised the angel that she would dedicate her child to God for the whole of her life. And Joachim was able to return to the Temple, reassured: "The Lord . . . hath forgiven all my sins" (Prot. James 5:1).

Giotto, *Joachim's Dream* (detail), 1304–06. Cappella Scrovegni (Arena Chapel), Padua.

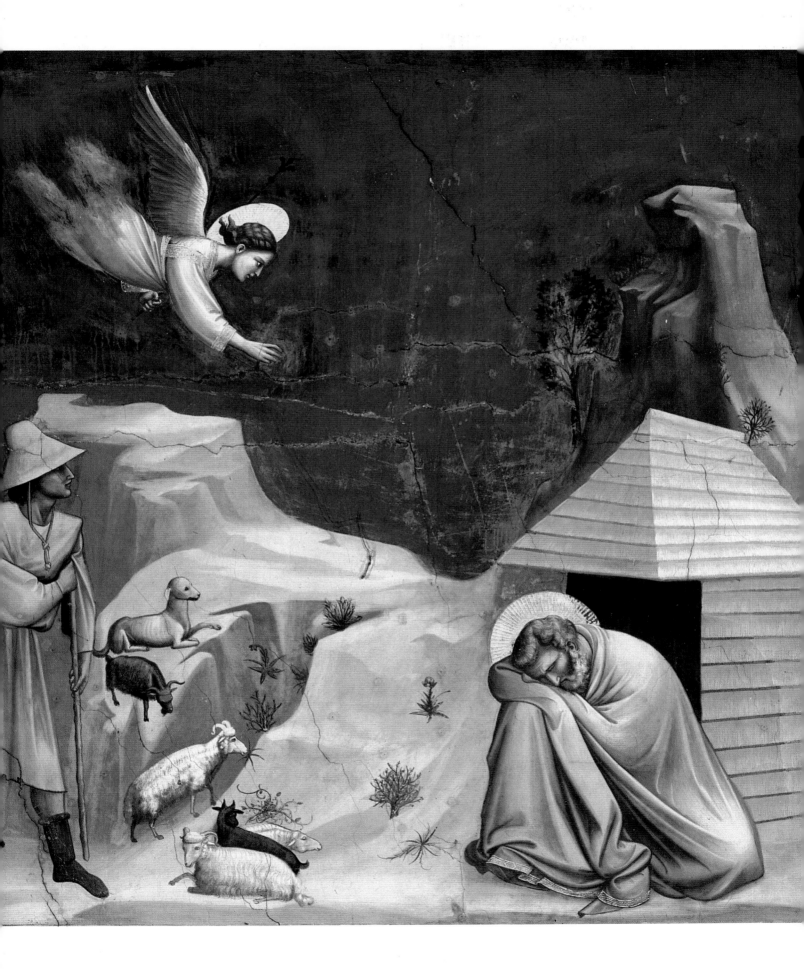

III THE IMMACULATE CONCEPTION

The dogma declaring that Mary was conceived without original sin—as opposed to the rest of humanity—was not proclaimed until the nineteenth century. In fact, it was Saint Augustine who in the fourth century coined the expression "original sin," referring to the transgression of Adam and Eve, and asserted that it tainted all human beings. For him, Mary was no exception. This sparked off a heated debate among theologians, priests, and religious figures that was to lead to the proclamation of the dogma fourteen centuries later. However, one thing was, and still is, certain for all Christians: Mary's purity.

Francisco de Zurbarán, *Immaculate Conception*, 1661. Museum of Fine Arts, Budapest.

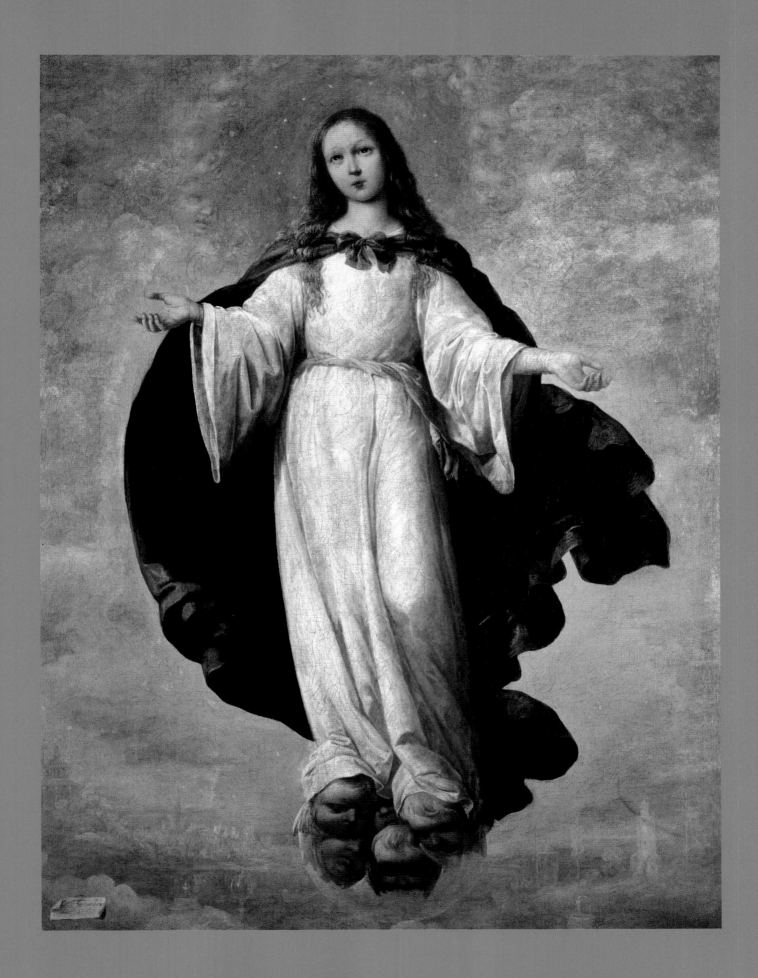

IV THE BIRTH OF MARY

According to the Protevangelium of James, Anna gave birth
during her seventh month of pregnancy, whereas the Pseudo-
Matthew says she was in her ninth month. Although they often
provide accounts of extraordinary detail, both apocryphal
Gospels say very little about the birth of Mary. James
emphasizes Anna's joy on hearing that her child is a girl.
This is a somewhat surprising reaction as girls were not highly
valued. Also unusual is the fact that Anna named the child, as
this privilege was most often reserved for the father. Indeed, in
the Gospel according to Matthew—probably dating to the last
twenty years of the first century—it was Joseph who gave Jesus
his name. Several decades later, James significantly assigned
the father Joachim a lesser role.

Vittore Carpaccio, *Birth of the Virgin*,
1504–08. Accademia Carrara, Bergamo.

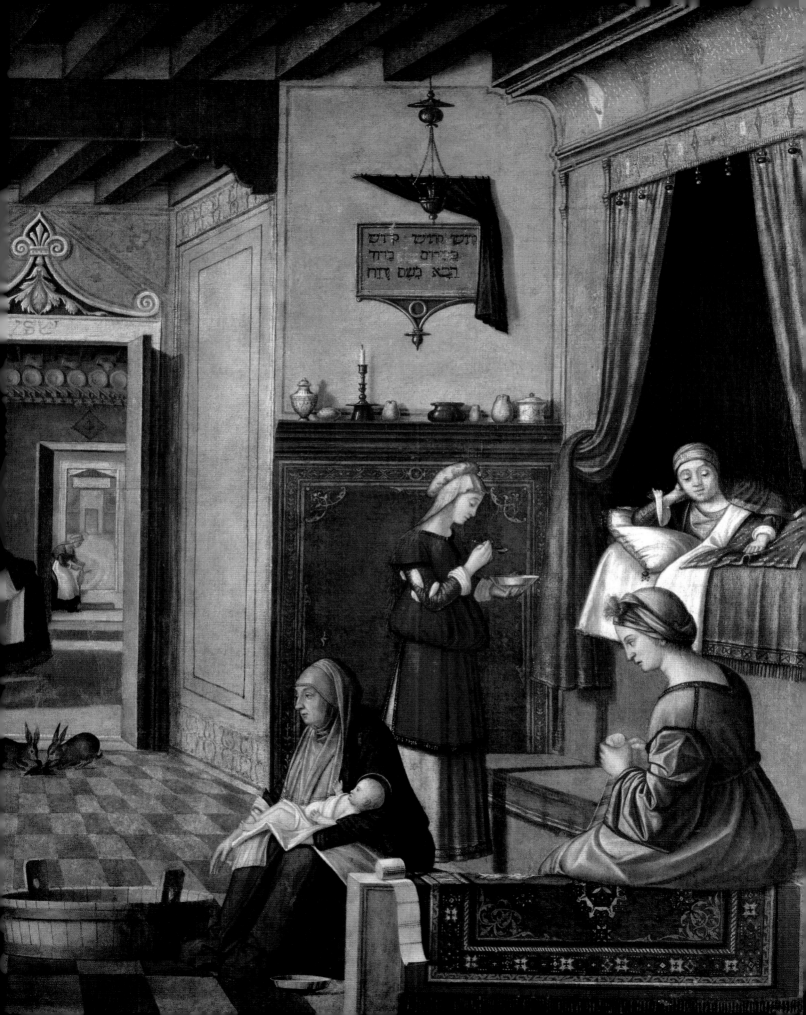

It is easy to imagine Mary as a child: a pretty little Jewish girl called Myriam, who was of course as good as gold, happy in spirit—and pious. Yet the canonical Gospels (as mentioned above, those accepted by most Christian churches) tell us nothing about her. She was probably born around 18 B.C.E., in all likelihood in Nazareth, a little village in Galilee that was a hub for caravans, purchasers of olives, and immigrant workers. In northern Palestine, Galilee was a pleasant flower-filled region that was sometimes clouded by revolts against Roman occupation, compounded with Herod's tyrannical rule and crippling taxes on farmers.

Only the Protevangelium and Pseudo-Matthew mention Mary's girlhood; they portray her as the very incarnation of virginity. Since her earliest years, every effort had been made to make sure that she would meet no men but priests. When she was three years old, her parents presented her at the Temple. She managed to slip away from them, as Titian's famous painting shows. At the beginning of the twentieth century, Rainer Maria Rilke, the poet from Prague, described the scene as follows:

> But she stole away from them [her parents],
> so small, slipping from their grasp
> to enter her destiny, which was loftier than the temple
> and already surpassed the edifice in perfection.

According to the Protevangelium of James, she remained in the Temple "as a dove" and "received food from the hand of an angel" (Prot. James 8:1). The Pseudo-Matthew portrays Mary as a cloistered nun before such a thing existed, praying, weaving from the third to the ninth hour, and being educated by "older virgins" (Pseudo-Matt. 6:2). She was fed by angels who conversed with her. She would give to the poor the food allotted to her by the priests. These accounts not only inspired artists, they also greatly contributed to a widespread devotion to Mary.

Titian, *Presentation of the Virgin at the Temple* (detail), 1534–38. Gallerie dell'Accademia, Venice.

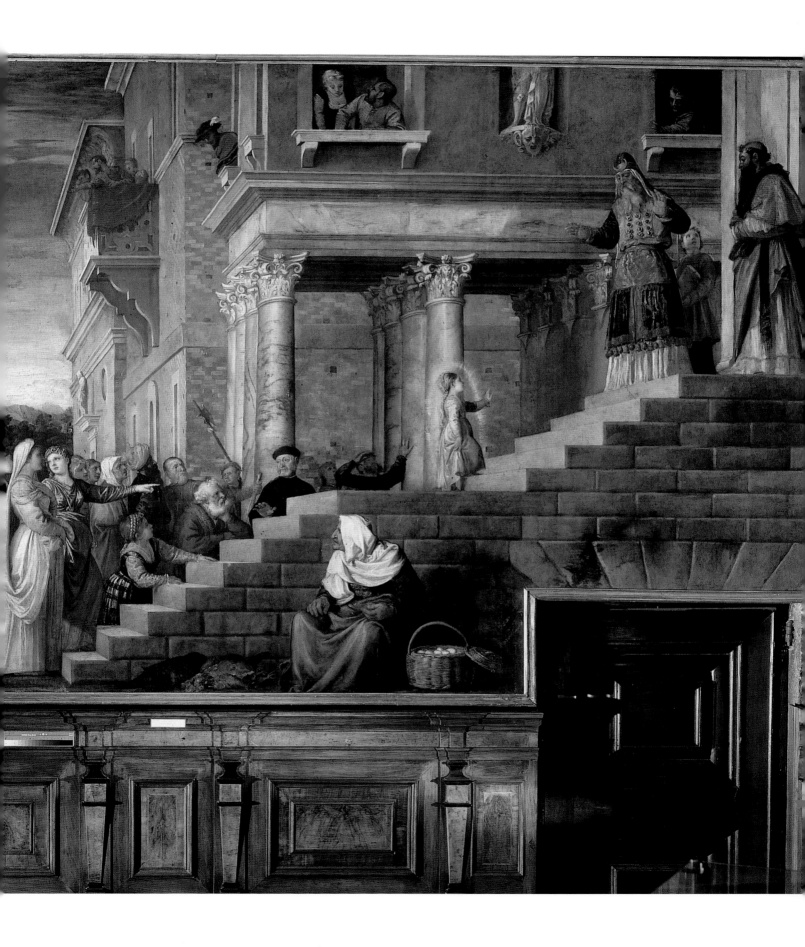

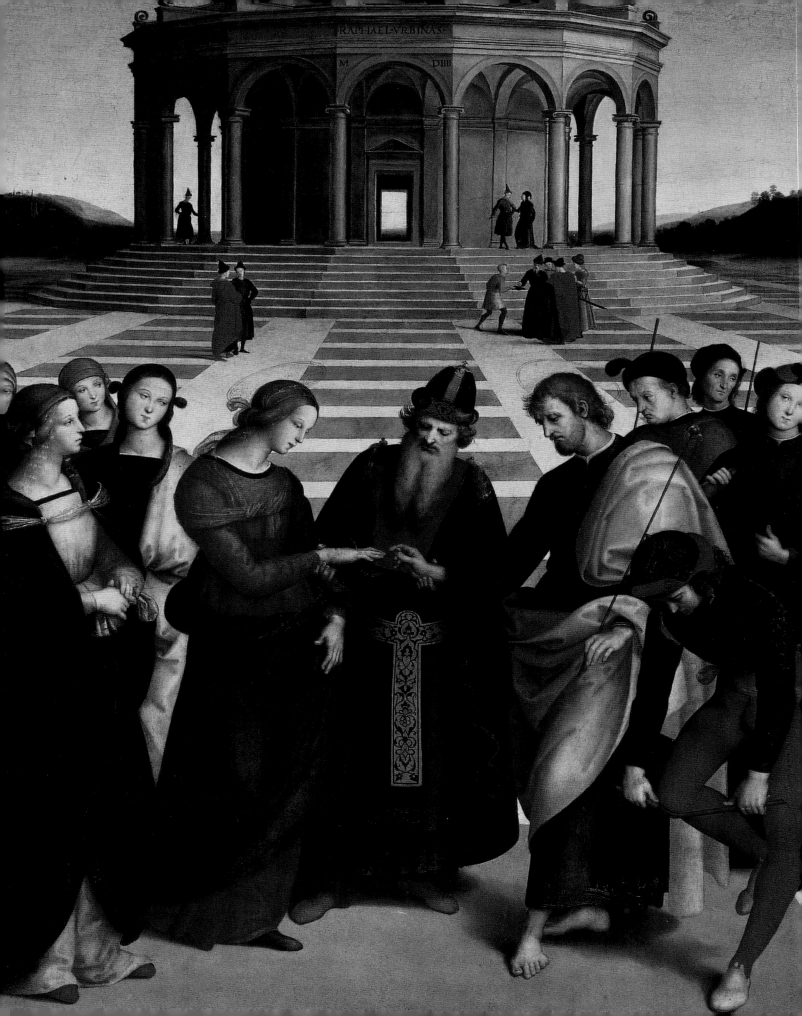

VI THE MARRIAGE OF MARY AND JOSEPH

In Jewish practice, at that time, there were two stages to marriage: first a mutual agreement, followed (after a variable period of time) by the young woman entering the bridal chamber in her spouse's home. Engagement as such did not exist. While the canonical Gospels tell us virtually nothing about the marriage of Mary and Joseph, the texts by James and the Pseudo-Matthew go into a wealth of fantastical detail. The high priest summoned all the widowers of the country, in order to choose a husband for Mary, advising each to bear a rod, as is shown in the painting by Raphael. As a dove finally emerged from the rod borne by an old man called Joseph, he was selected. However, as Pseudo-Matthew is quick to point out, he would be merely Mary's keeper, as she had vowed "that she [would] remain a virgin to God" (Pseudo-Matt. 8:1). This gave rise to the belief in Mary's will to remain a virgin forever. What is more, Joseph—an old man who was a widower from a previous marriage—already had children and grandchildren. This is why some consider that when the four canonical Gospels speak of Jesus' brothers and sisters, they are really referring to his half-brothers and half-sisters.

Raphael, *Marriage of the Virgin* (detail), 1503–04. Pinacoteca di Brera, Milan.

Fra Angelico, *Annunciation* (detail), c. 1450. Monastery of San Marco, Florence.

The Annunciation

The Gospel of Luke—the only one of the four Evangelists to give an account of the Annunciation to Mary—is suffused with joy. The tone is set by the first words uttered by the angel Gabriel: "Rejoice, you who enjoy God's favour!" (Luke 1:28). Yet Mary has her doubts. The angel is quick to reassure her. And in the end she sings the "Magnificat": "My soul proclaims the greatness of the Lord" (Luke 1:46).

VII THE ANGEL APPEARS TO ZECHARIAH

In the Gospel according to Luke, the announcement to Mary is preceded by the one to Zechariah, an elderly, childless priest (like Joachim) whose formerly barren wife Elizabeth (like Anna) was miraculously to bear a son: John the Baptist. The angel Gabriel—whose name means "God's strength"—was the bearer of the glad tidings. But Zechariah's incredulity at the news was punished: he was struck dumb until his son was born. This is quite a different stance from that of Mary and Joseph. The elderly priest's skepticism is clearly illustrated in Ghirlandaio's painting.

Nevertheless, he uses a setting from his own epoch, as do almost all Renaissance painters. Moreover, this is historically inaccurate: in Jesus' time, women (who are pictured to the right) would not have been allowed in such proximity to the Holy of Holies of the Temple of Jerusalem.

Domenico Ghirlandaio, *Angel Appearing to Zechariah* (detail), 1485–90. Santa Maria Novella, Florence.

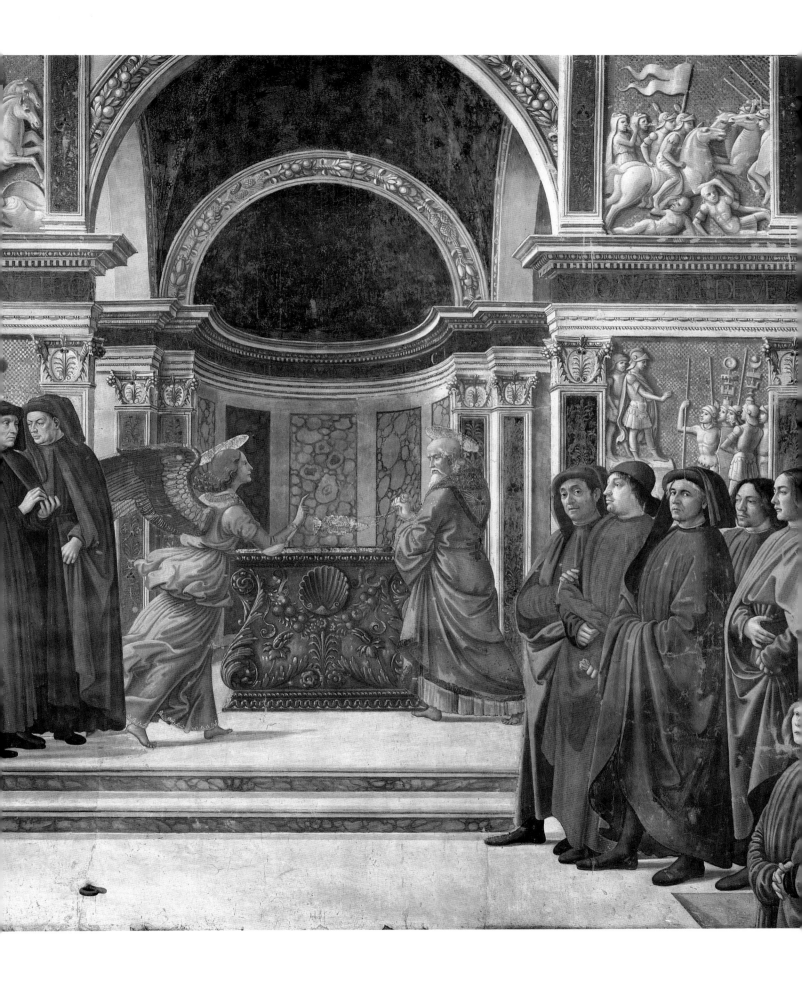

"In the sixth month the angel Gabriel was sent by God to a town in Galilee called Nazareth, to a virgin betrothed to a man named Joseph, of the House of David; and the Virgin's name was Mary. He went in and said to her, 'Rejoice, you who enjoy God's favour! The Lord is with you.' She was deeply disturbed by these words and asked herself what this greeting could mean, but the angel said to her, 'Mary, do not be afraid; you have won God's favour. Look! You are to conceive in your womb and bear a son, and you must name him Jesus. He will be great and will be called Son of the Most High'" (Luke 1:26–32).

Many artists have illustrated this episode from Luke, including the Dominican Fra Angelico in the fifteenth century. His painting on the facing page is the most famous representation of the Annunciation. Moreover, it is a highly symbolic work. To begin with, the small column set between the angel and Mary marks the separation of two worlds: that of men and of God. Yet the ray of light and fecundity draws these worlds together in the spirit of the Incarnation. In the background is the Garden of Eden—also found in many other representations—with its tree and fruit, and the figures of Adam and Eve emerging beneath God's watchful gaze. Marian devotion, highly developed in the East, was introduced to the West through art, mosaics in particular, as is apparent from the example found in the Basilica of Santa Maria Maggiore in Rome (p. 32). As was common practice in Byzantium, Mary is already depicted here as an empress receiving the angel Gabriel. Court dress and etiquette were painstakingly captured even down to the color—red—of the Virgin's footwear (p. 76). Ordinary women of Byzantium were not allowed to wear red, which was reserved for imperial attire.

Fra Angelico, *Annunciation* or *Prado Altarpiece*,
1430–32. Museo del Prado, Madrid.

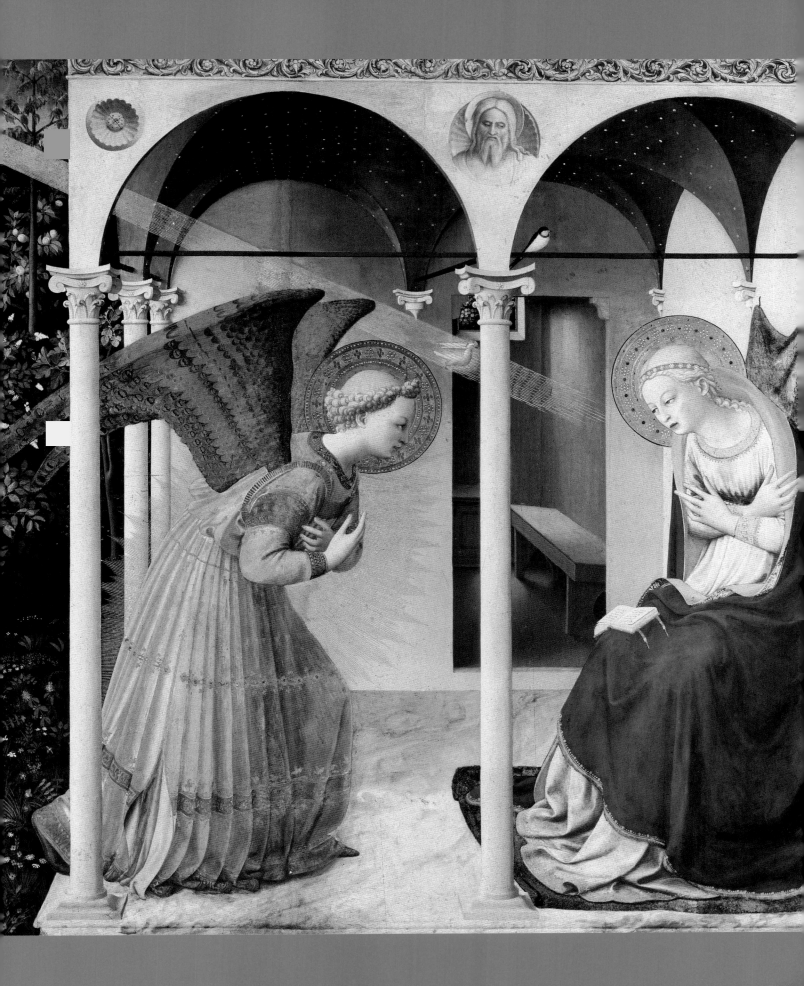

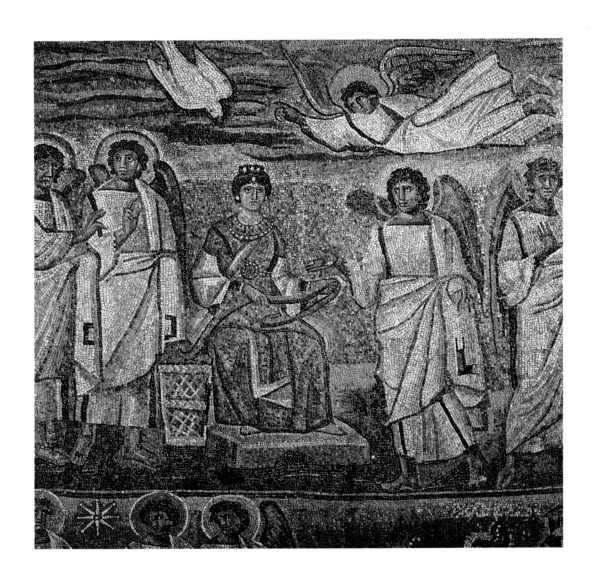

Annunciation, Scenes from the Childhood of Jesus (detail), 432–44. Basilica of Santa Maria Maggiore, Rome.
Facing page: Lorenzo Lotto, *Annunciation*, 1534. Pinacoteca Civica, Recanati.

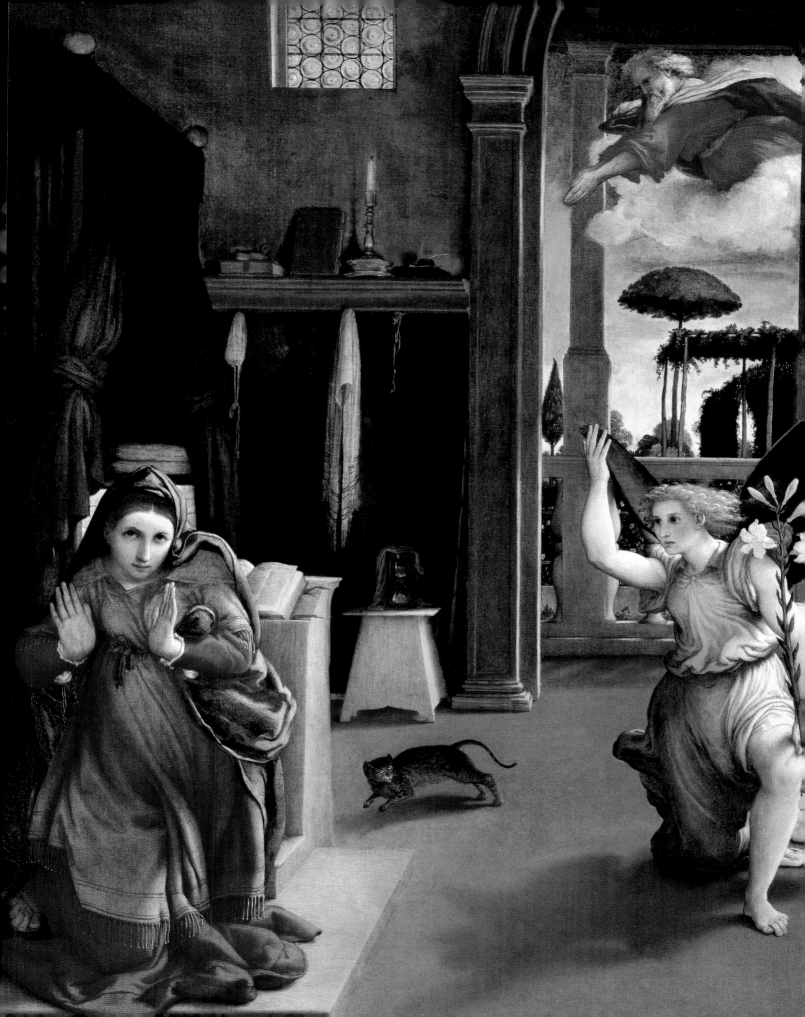

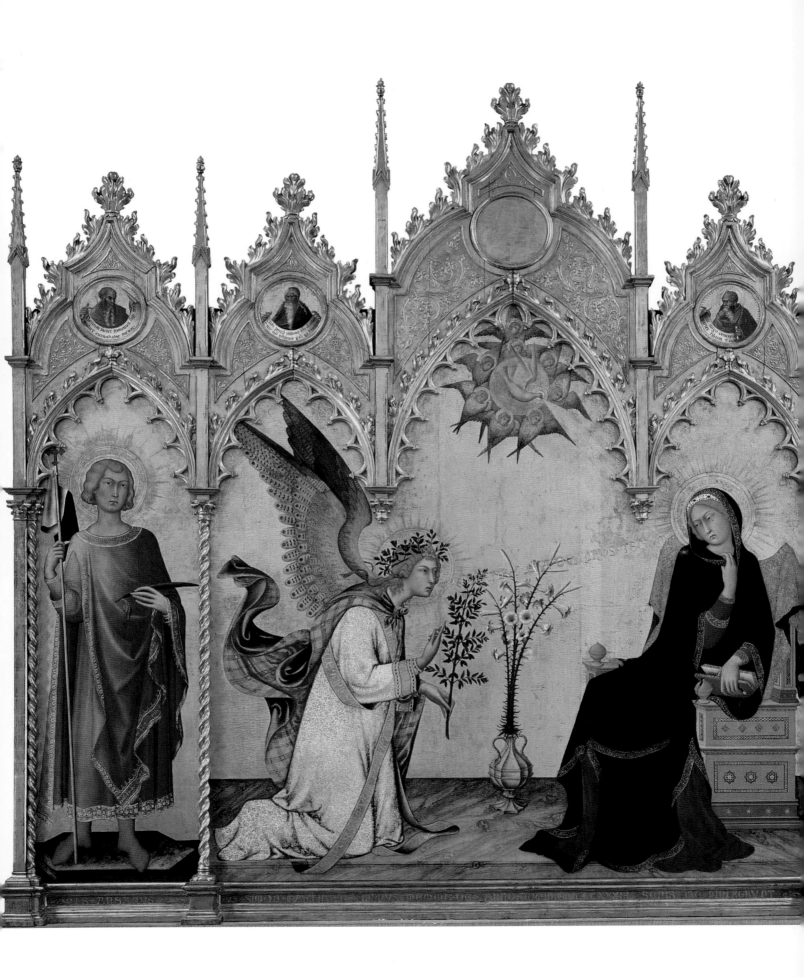

IX VIRGINAL CONCEPTION

"Mary said to the angel, 'But how can this come about, since I have no knowledge of man?' The angel answered, 'The Holy Spirit will come upon you, and the power of the Most High will cover you with its shadow. And so the child will be holy and will be called Son of God. And I tell you this too: your cousin Elizabeth also, in her old age, has conceived a son, and she whom people called barren is now in her sixth month, for nothing is impossible to God'" (Luke 1:34–37).

In order to illustrate the virginal conception, as described here by Luke, artists quickly adopted the convention of using a pigeon or dove (a bird often encountered in the Bible) to represent the Holy Spirit. A dove also appears during the baptism of Jesus by John the Baptist. Another device is to portray the angel bearing an olive branch, as does fourteenth-century artist Simone Martini, who shows the angel speaking. Indeed, the church fathers and various poets have entertained the idea of Mary being impregnated by the Word of God, highly symbolic in nature. Carpaccio (p. 36) allows us a rare glimpse of Mary's bed, while Filippo Lippi (p. 37), paying attention to the rules of perspective, is careful to segregate the human world with the fair-haired Virgin at its center and the realm of God and angels. Even the respective floors have different tiling, those to the left being more sumptuous.

Simone Martini, *Annunciation*, 1333. Galleria degli Uffizi, Florence.

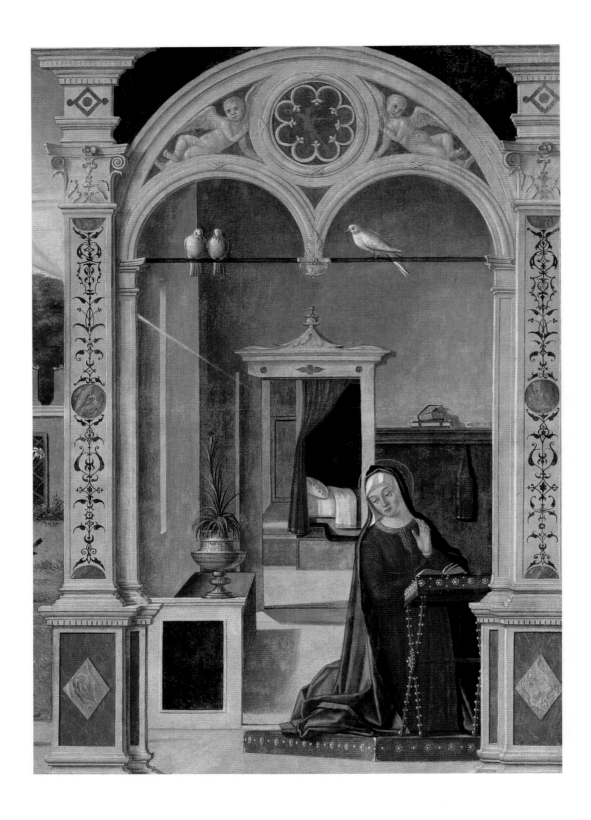

Vittore Carpaccio, *Annunciation* (detail), 1504. Ca' d'Oro, Venice.
Facing page: Fra Filippo Lippi, *Annunciation* (detail), 1466–69. Duomo, Spoleto.

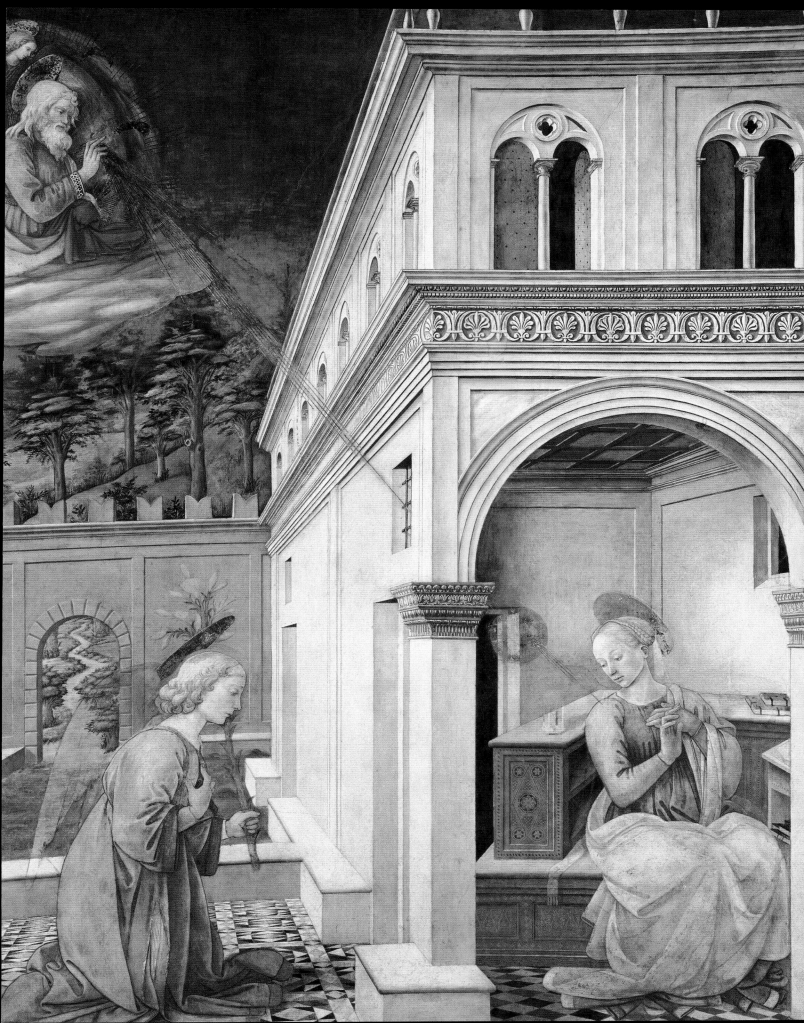

According to Luke, on hearing the angel's message, Mary "was deeply disturbed"
(Luke 1:29). Yet she was not so afraid as the painting by Tintoretto (pp. 40–41) suggests,
apparently inspired by the Protevangelium of James that speaks of her "being filled with
trembling" (Prot. James 11:1). In fact, Gabriel is bringing her glad tidings—"Evangelion"
actually means "good news." Unlike Zechariah, Mary trusts in the angel's words and asserts
her faith by replying: "You see before you the Lord's servant, let it happen to me as you
have said" (Luke 1:38).

Dante Gabriel Rossetti, *Ecce Ancilla Domini* (The Annunciation), 1849–50. Tate Gallery, London.
Following pages: Tintoretto, *Annunciation*, 1583–87. Scuola Grande di San Rocco, Venice.

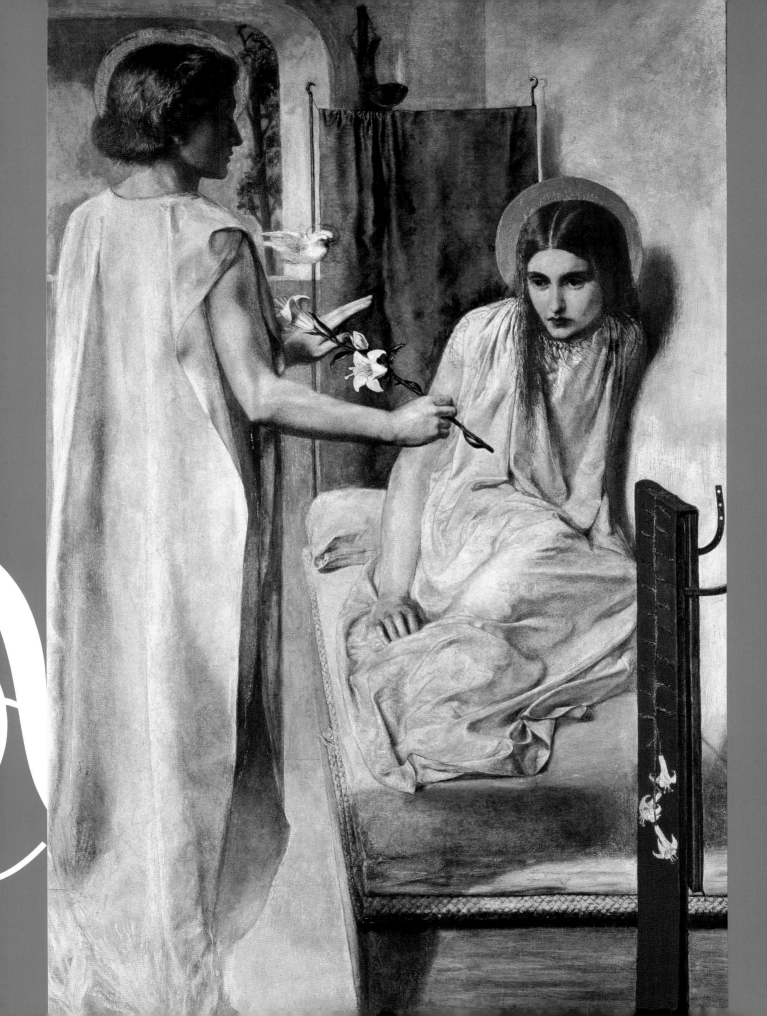

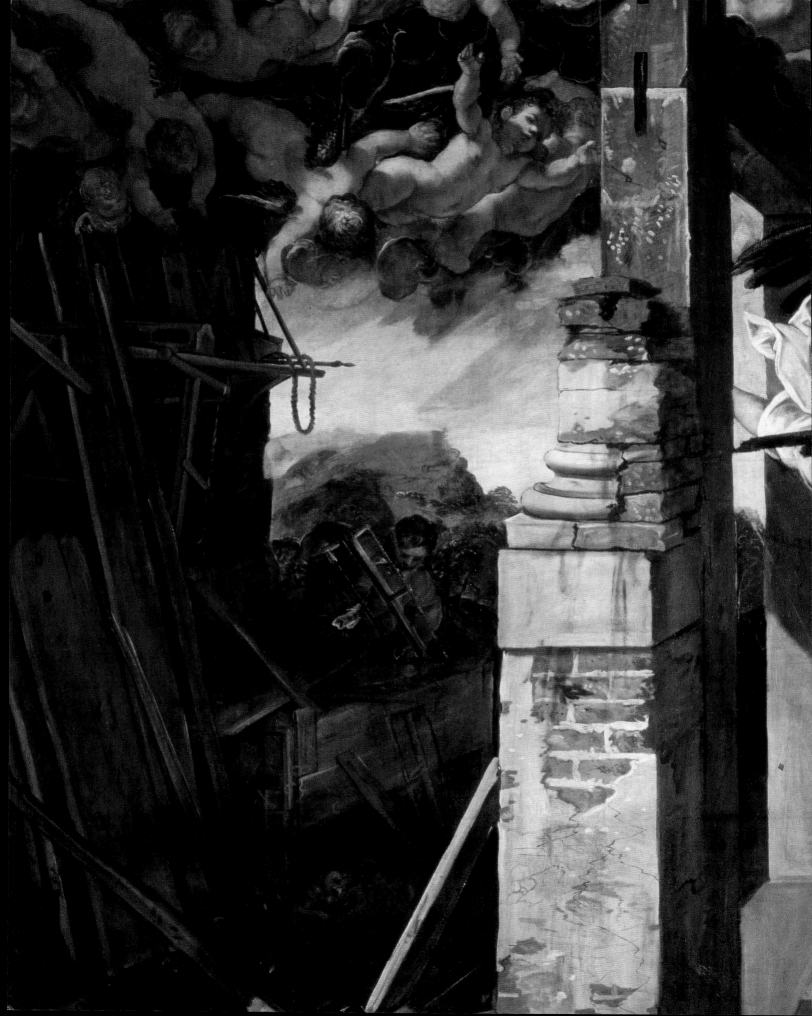

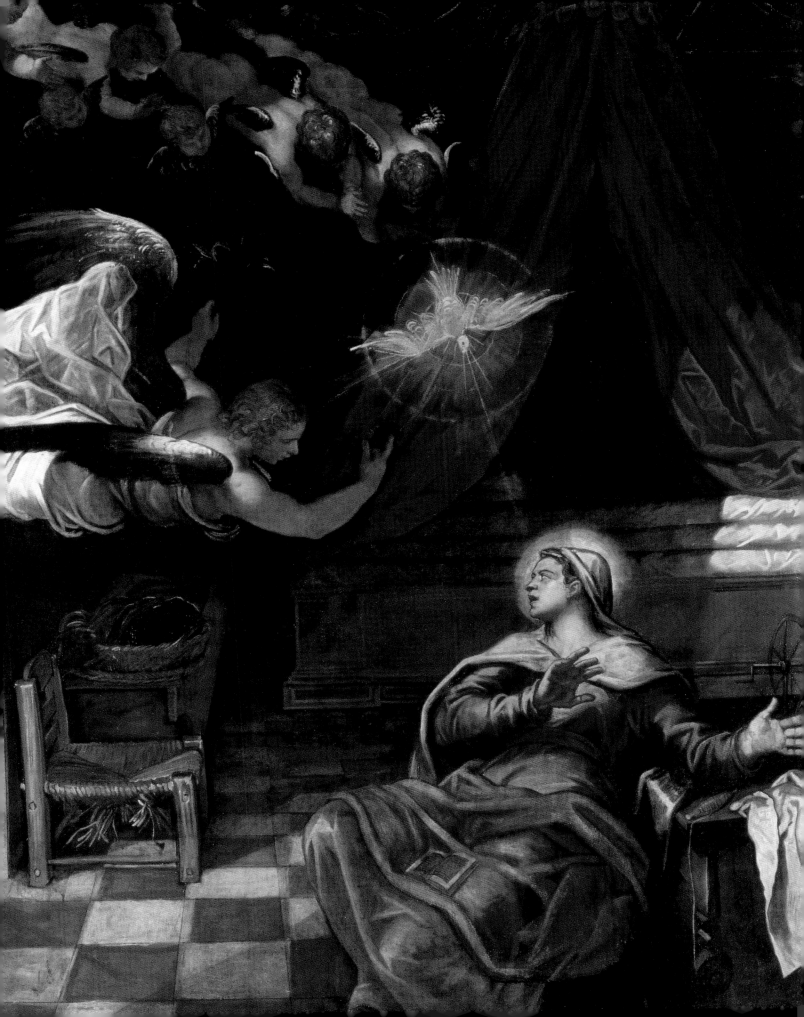

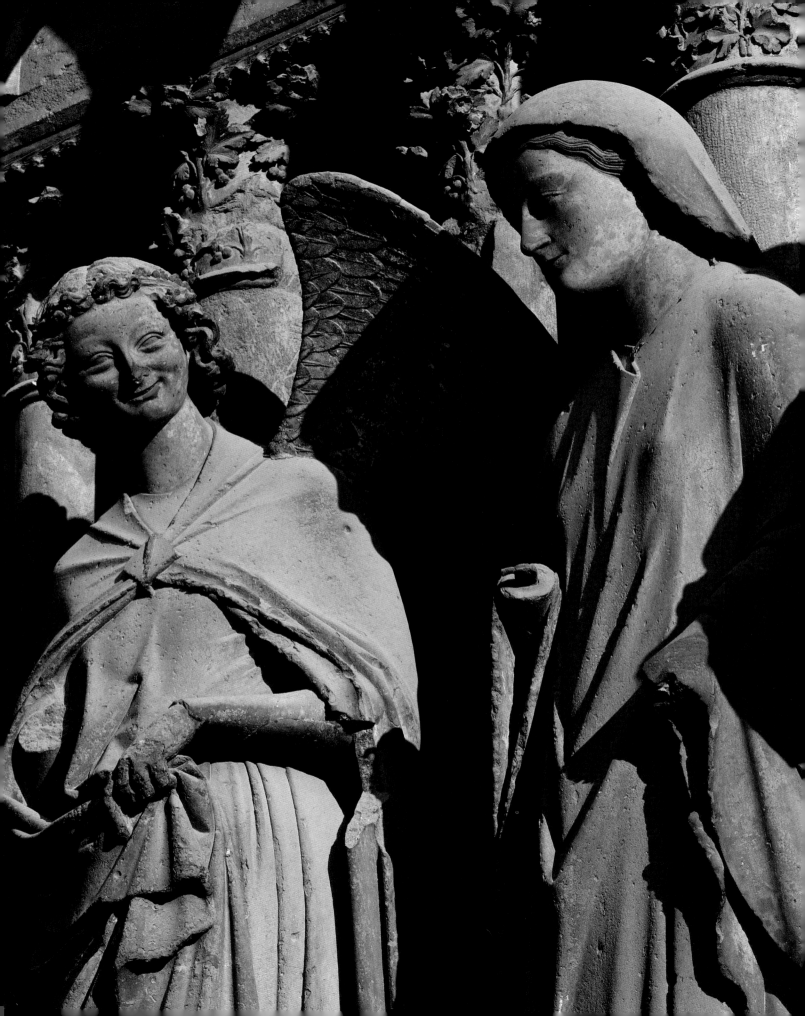

XI THE ANGEL

Having delivered the message, the angel leaves contentedly. The angel's smile was captured in a stone effigy on the west façade of the cathedral in Reims. Indeed, this whole episode is suffused with joy—as is the birth of Jesus, which Luke describes as being celebrated by a choir of angels, "a great throng of the hosts of heaven" (Luke 2:13).

Annunciation, 1232. Cathedral of Notre-Dame, Reims.

XII MARY IS WITH CHILD

Belief in the Incarnation took shape in the West during the Middle Ages as a means of restoring faith in humanity and the earth itself. Until that point, Mary was generally portrayed wearing dark hues in mourning for her son. As most colors were linked with the material world, they were not appropriate for Mary. Blue was the only shade associated with heavenly light, which explains why it began to be associated with Mary from this time on. It indicates the reconciliation of heaven and earth as symbolized by Mary, depicted here pregnant and full of hope.

Piero della Francesca, *Madonna del Parto*, 1450–55. Cappella del Cimitero, Monterchi (Arezzo).

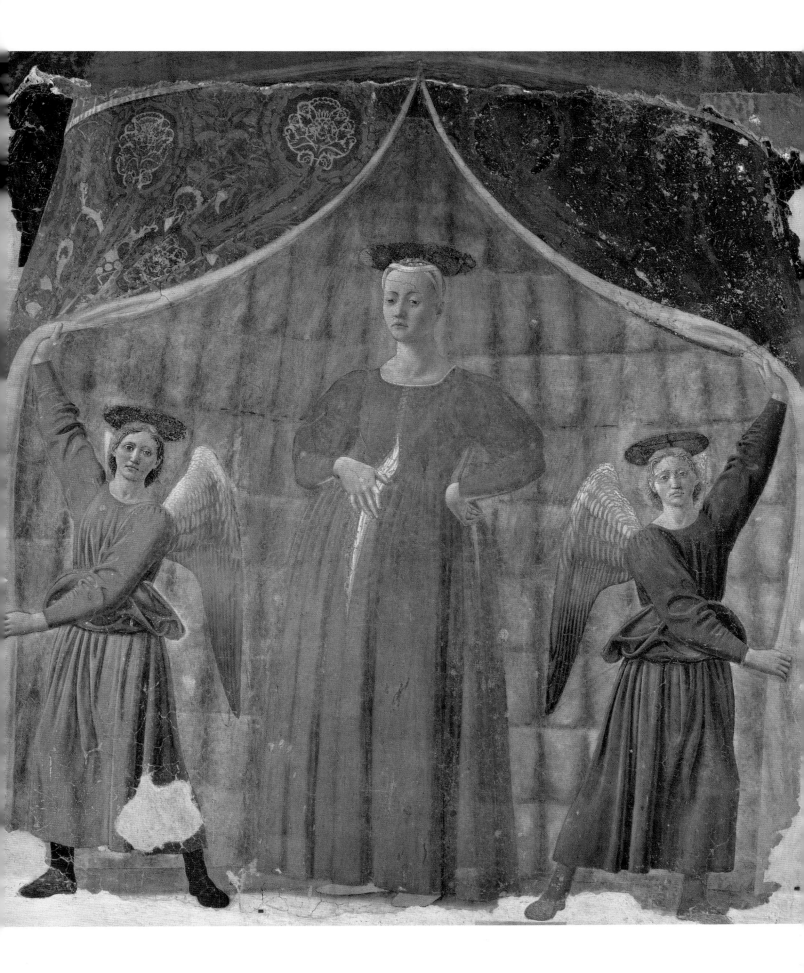

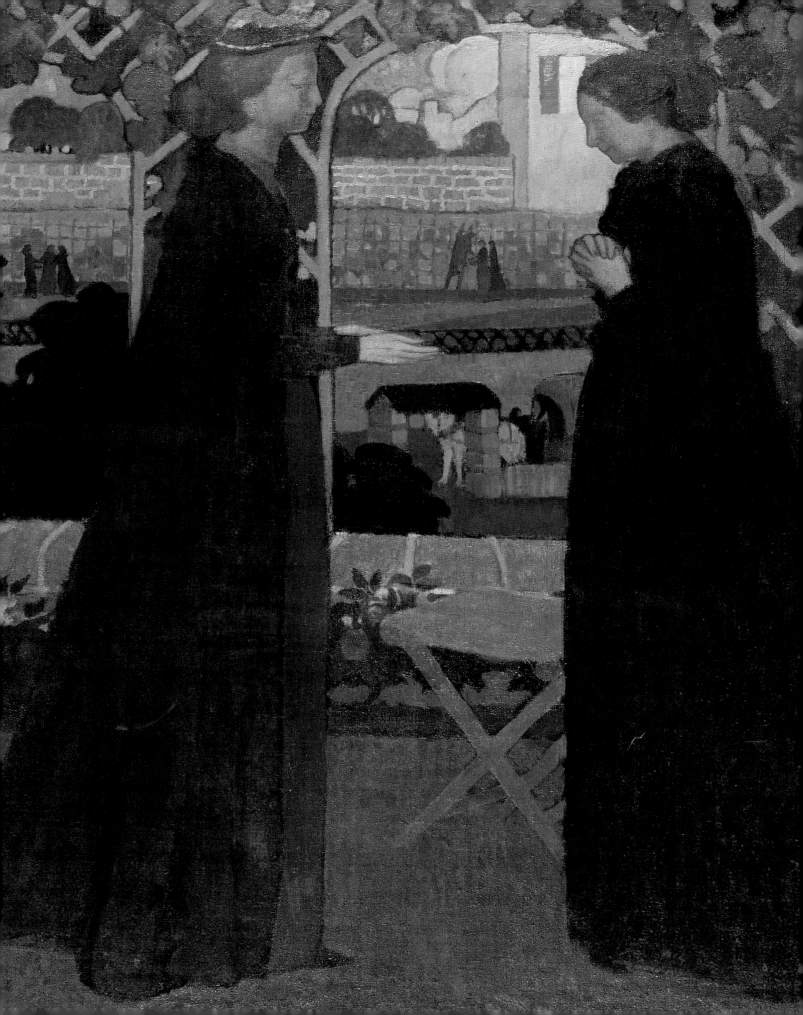

XIII THE VISITATION

What does a woman usually do when she is delighted to find she is pregnant? She shares the news with her nearest and dearest—in this case a cousin, Elizabeth, who is also expecting and will soon give birth to John the Baptist. We may be tempted to forget the symbolic meaning of this visit, remembering only the touching image of mutual joy.

In this nineteenth-century painting, Mary (wearing a hat) holds out her hands in greeting as she is welcomed by Elizabeth. The latter's hands are clasped together in veneration. The Gospel according to Luke describes how the child (John the Baptist) "leapt in (Elizabeth's) womb" (Luke 1:41) and how Elizabeth "filled with the Holy Spirit" called Mary "the mother of my Lord" (Luke 1:42–43).

In the fifteenth century, Domenico Ghirlandaio had already depicted Elizabeth (the elder woman, as we know) kneeling before a youthful Mary (p. 48). On several occasions, the Evangelists took pains to show that Jesus was superior to John the Baptist, as rivalry was not unheard of between their respective disciples.

Maurice Denis, *The Visitation*, 1894. Hermitage Museum, Saint Petersburg.

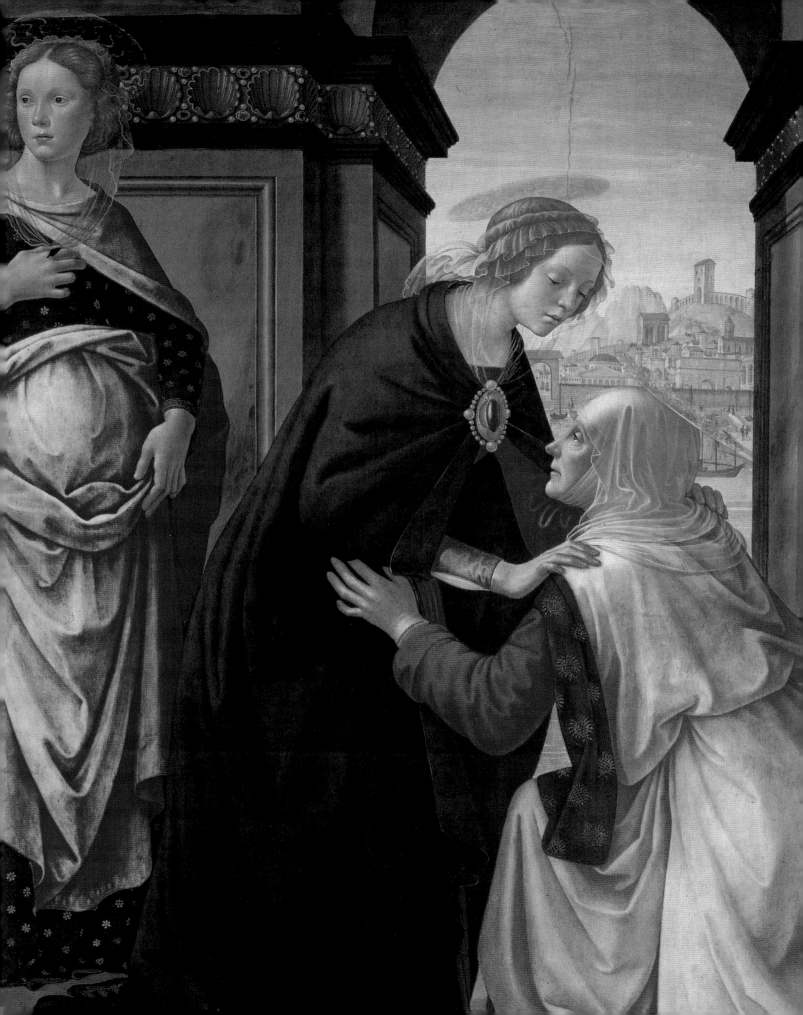

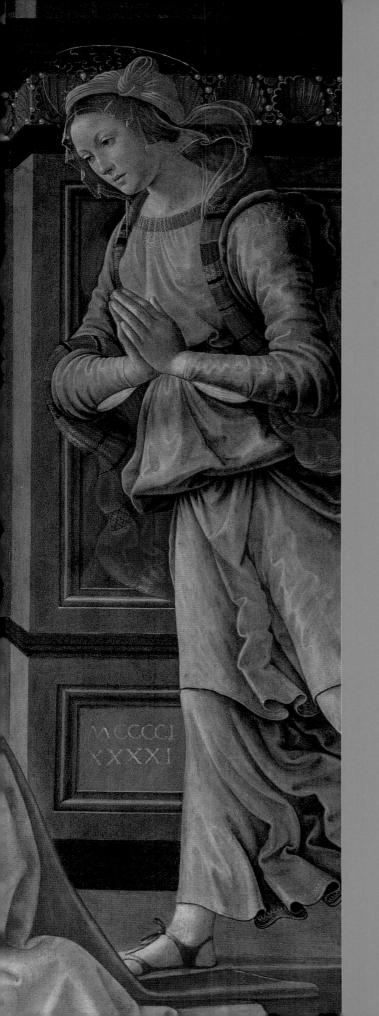

Domenico Ghirlandaio, *The Visitation* (detail),
1491. Musée du Louvre, Paris.

Raphael, *Madonna dell Granduca* (detail), 1504–05. Galleria Palatina, Palazzo Pitti, Florence.

The Nativity

"Noel, Noel, Noel, Noel, Born is the King of Israel," the Christmas carol proclaims. It was a birth that would alter the course of world history. From then on there would be "before" and "after" the moment that "God was made man and man was made God," as formulated by the third-century martyr, Hippolytus of Rome. This is a fundamental belief of Christianity.

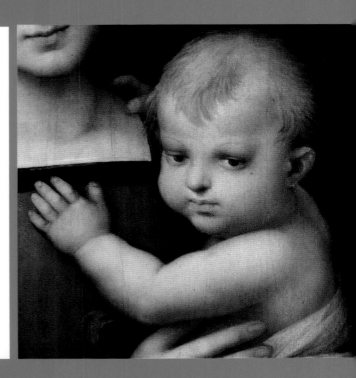

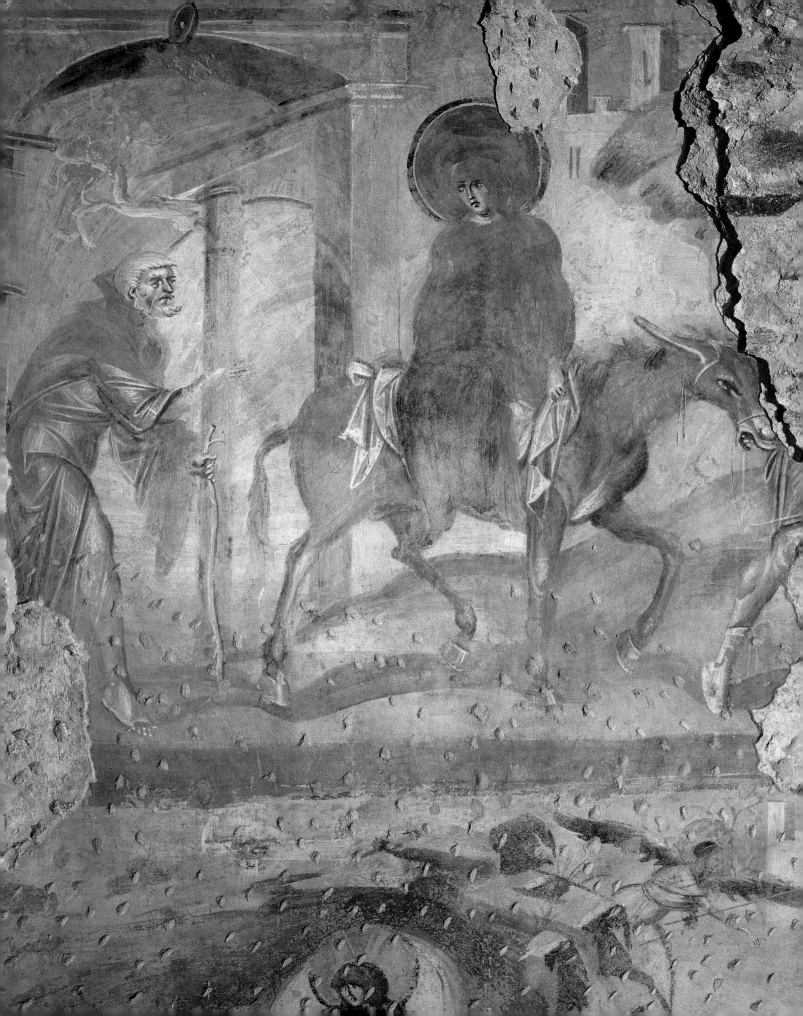

Luke tells us that in those days "Caesar Augustus issued a decree that a census should be
made of the whole inhabited world" (Luke 2:1). Everyone "went to be registered, each
to his own town. So Joseph set out from the town of Nazareth in Galilee for Judaea,
to David's town called Bethlehem, since he was of David's House and line, in order
to be registered together with Mary, his betrothed, who was with child" (Luke 2:3–5).
No reference to this census can be found in any contemporary document. Yet this
Byzantine mural painting is principally concerned with the affection between two people.
Mary is, of course, in front, encircled with a halo. Joseph watches over her and the unborn
child, his gaze never wavering.

The mystery of the Incarnation begins afresh from day to day, continually renewed.
Who would reproach Pieter Bruegel the Elder (pp. 54–55) for setting the census in a
"Flemish-style" Bethlehem? A throng of people crowd round the inn. It is hardly surprising
that there is no room left for Mary and Joseph. The son of God—God himself become
man—was therefore born in a stable, lowly among the lowly.

Mary and Joseph on the Road to Bethlehem (detail), 650. Church of Santa Maria Foris Portas, Castelseprio.
Following pages: Pieter Bruegel the Elder, *The Numbering at Bethlehem*, 1566. Musées Royaux des Beaux-Arts, Brussels.

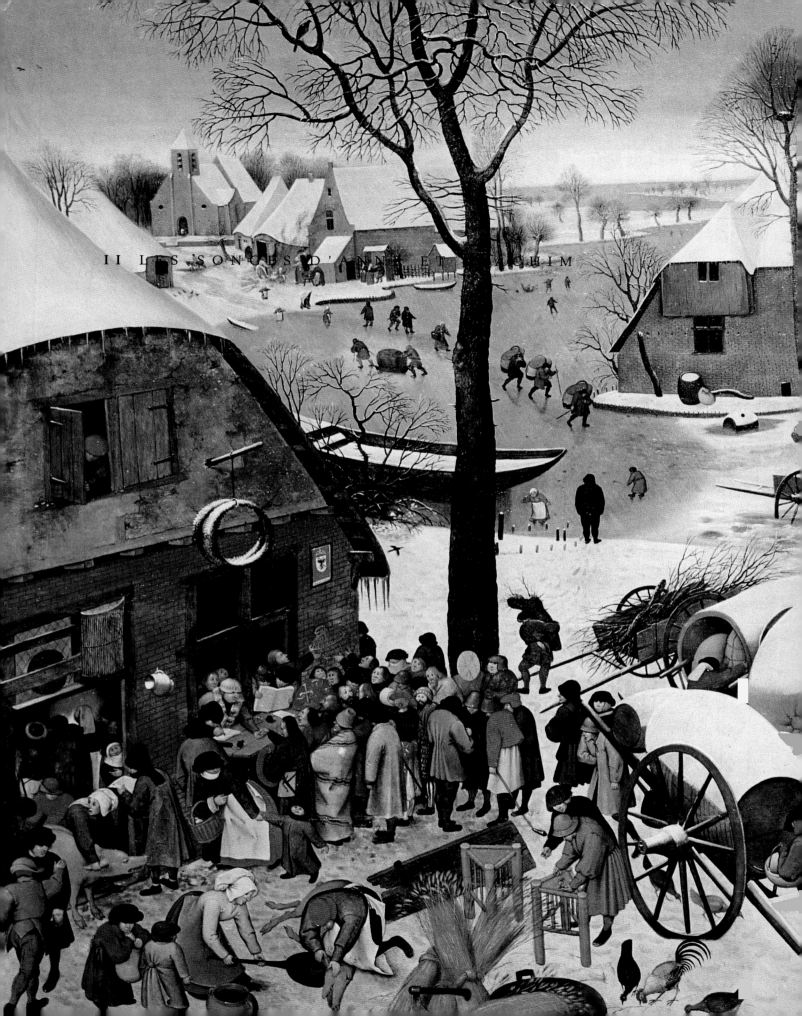

II LES SONGES D'ANNE ET JOACHIM

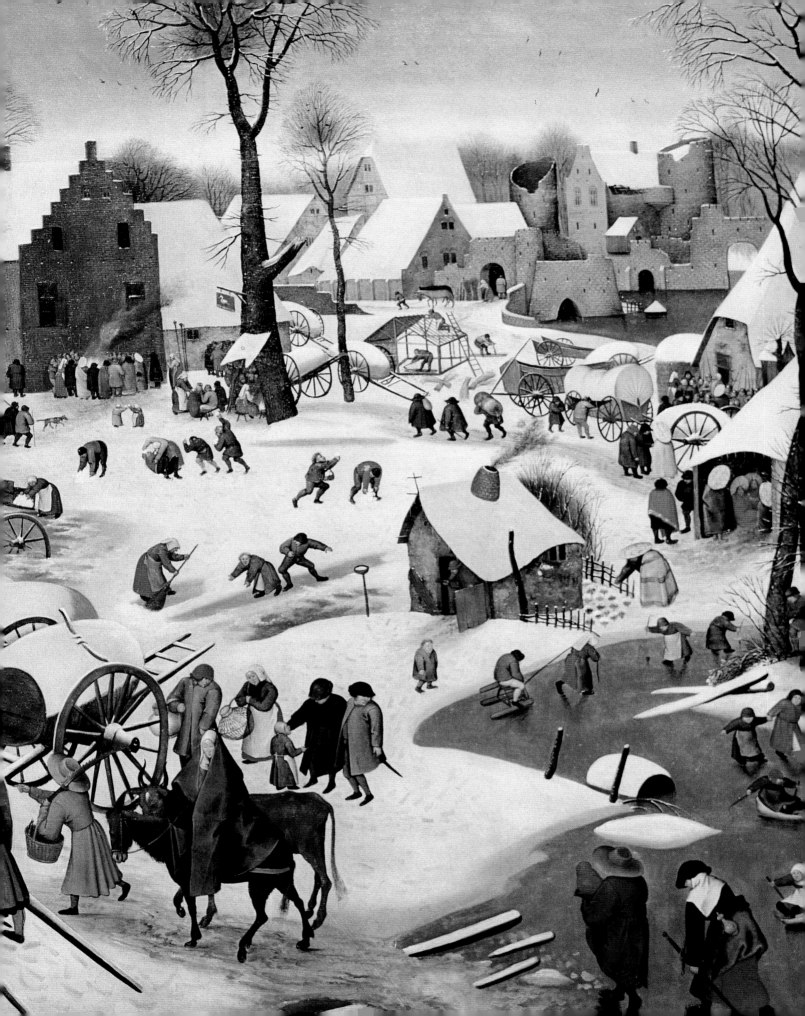

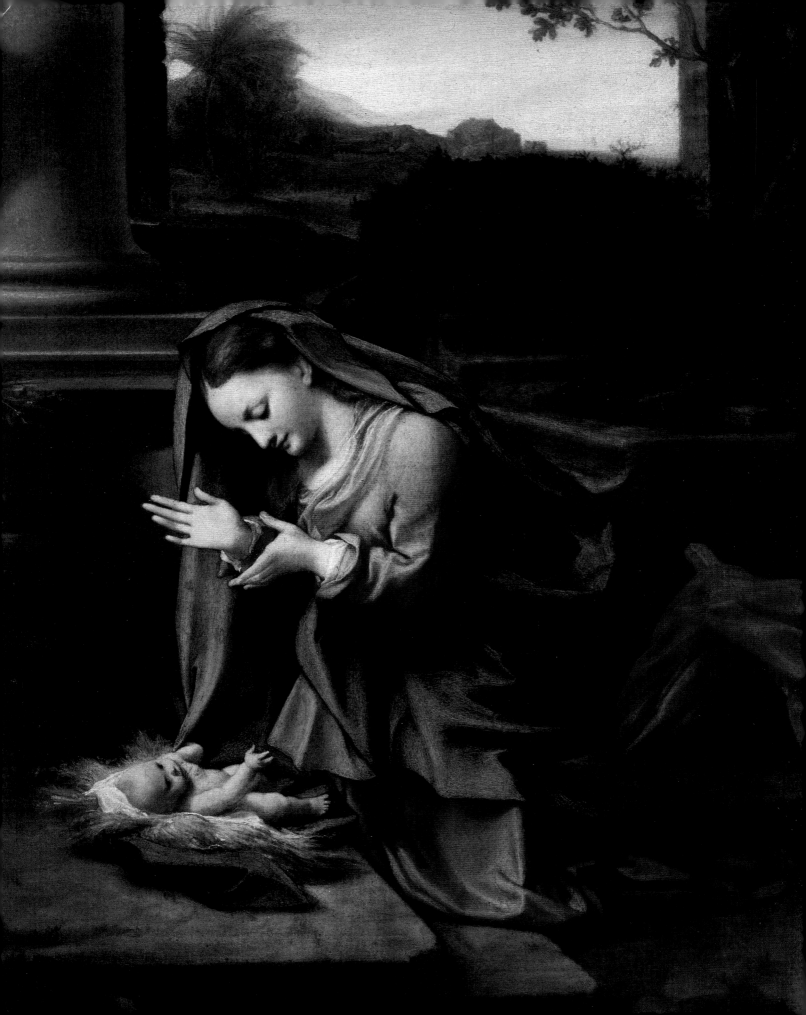

Mary "gave birth to a son, her first-born. She wrapped him in swaddling clothes and laid him in a manger" (Luke 2:7). Luke's description is very matter-of-fact, despite the importance of the event. Matthew gives no account of the birth, mentioning only that Joseph named the baby Jesus as instructed by "an angel of the Lord" (a term often used in Holy Scriptures to refer to God himself) who had "appeared to him in a dream and said, 'Joseph son of David, do not be afraid to take Mary home as your wife, because she has conceived what is in her by the Holy Spirit. She will give birth to a son and you must name him Jesus, because he is the one who is to save his people from their sins'" (Matt. 1:20–21).

Mary is beautiful and meditative. Although a colonnade is unlikely to be found in a stable, Correggio wanted to show that this baby, in all his nakedness and radiance, is no less than a king. As such, he deserves a palace more gorgeous than any on this earth, where a new day is dawning.

In the painting by Charles Poerson (p. 59) the Christ Child is already able to stretch out his arms to Mary. The angels watching over them are poised to spread the good news.

Angels are a common subject in devotional images. The word "angel" comes from the Greek meaning "messenger." Pope Saint Gregory maintained that angels only deserve their name when they are harbingers of news. But popular piety ascribed other roles to them, such as guardians, musicians, singers, or guides. The Catholic Church has always been quick to stress that they were subordinate to Christ. The apostle Paul wrote in his letter to the Colossians (dating to 62 or 63) that in Jesus "were created all things in heaven and on earth: everything visible and everything invisible" (Col. 1:16). Angels have suffused Christian iconography with their beauty from Byzantine art to contemporary painting.

Correggio, *Madonna Worshipping the Child* (detail), 1524–26. Galleria degli Uffizi, Florence.

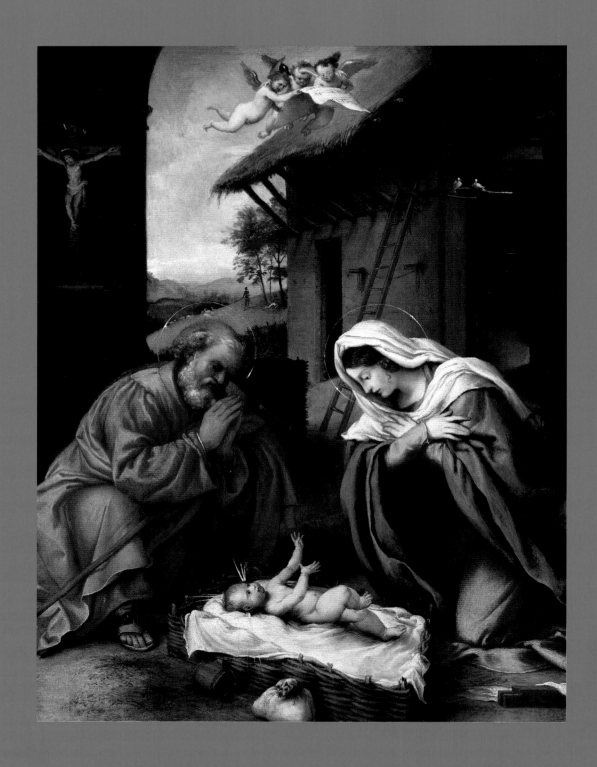

Lorenzo Lotto, *Nativity*, 1523. National Gallery, Washington.
Facing page: Charles Poerson, *Nativity* (detail), c. 1645. Musée du Louvre, Paris.

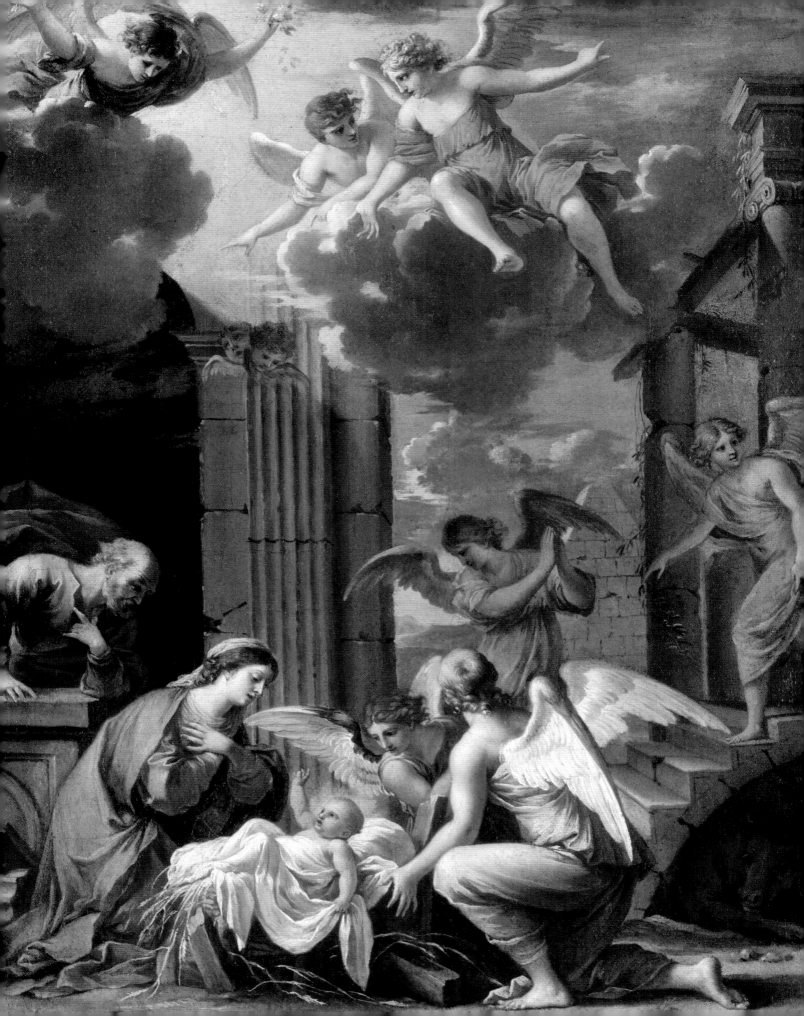

XVI THE ANGEL APPEARS TO THE SHEPHERDS

The shepherds were there for a reason. At the time, they were considered as lowly individuals, as worthless misfits. Yet they were the chosen ones and an angel appeared to summon them. Their initial reaction was one of fear (as is usually the case with angelic apparitions in the Bible). But the angel reassured them, saying: "I bring you news of great joy, a joy to be shared by the whole people. Today in the town of David a Saviour has been born to you; he is Christ the Lord" (Luke 2:10–11). "So they hurried away and found Mary and Joseph, and the baby lying in the manger" (Luke 2:16).

The outcasts were the first to be told. The last shall be first.

Leandro Bassano, *Annunciation to the Shepherds*, 1590. Musei Civici, Padua.

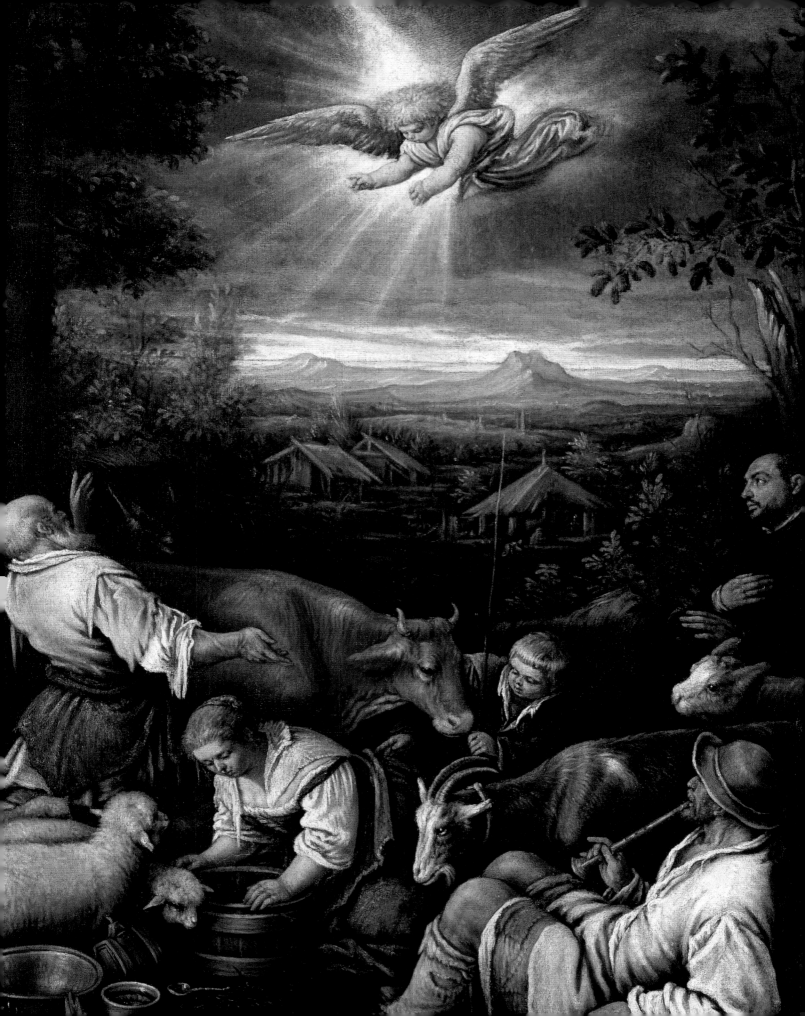

XVII THE ADORATION OF THE SHEPHERDS

Take a good look at these shepherds, who were the first to come and worship Jesus. They do not look very commendable. They could well be dishonest rogues or thieves. There is even a saying that goes "do not rescue the *goïm* (heathens) and shepherds who fall down a well."

But there is a festive atmosphere, with everyone clamoring to see the baby.

Mary welcomed the visitors. According to Luke, "when they saw the child they repeated what they had been told about him, and everyone who heard it was astonished at what the shepherds said to them. As for Mary, she treasured all these things and pondered them in her heart" (Luke 2:17–19). Almost as radiant as the Christ Child, it is also her that the shepherds come to see.

Perhaps each one was thinking of Mary's special grace, as did Martin Luther, who admired Mary in his early writings. In 1520, Luther published a commentary on the "Magnificat,"— Mary's song in response to the Annunciation. Luther found that while Catholics often exaggerated Mary's role, she was a pious example as a disciple of Jesus and the "Spiritual Mother" of the faithful. Calvin, on the other hand, refused to observe Marian feast days. Yet Catholics often overestimate Protestants' opposition to Mary's role in the Christian church.

Hugo van der Goes, *Adoration of the Shepherds*, 1476. Galleria degli Uffizi, Florence.

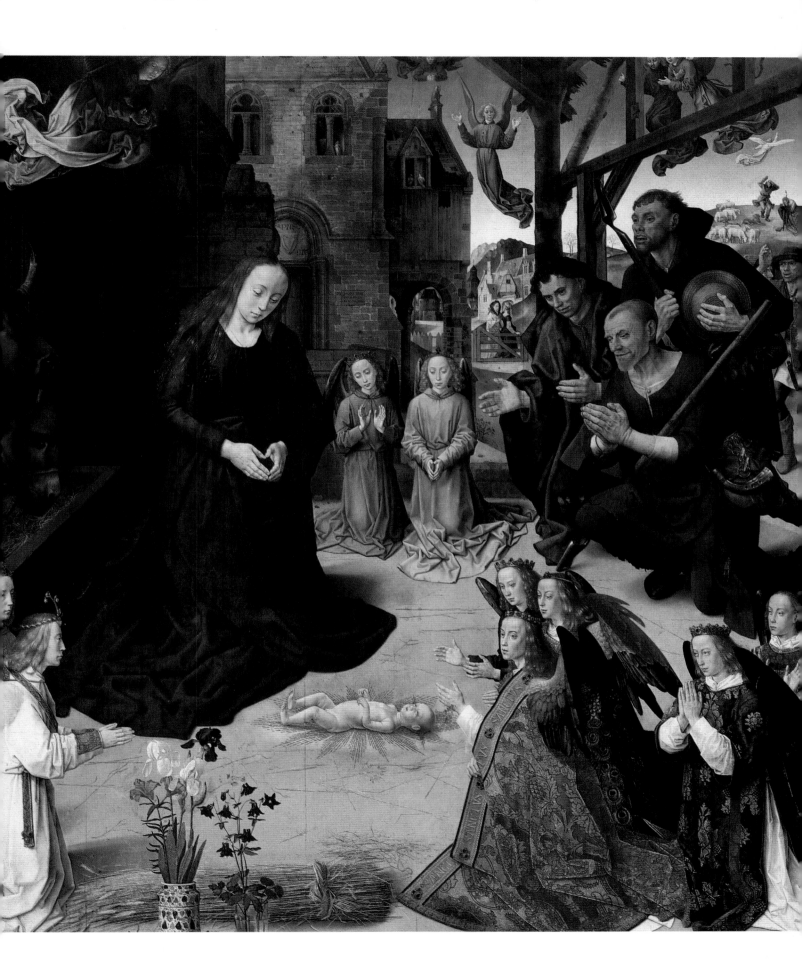

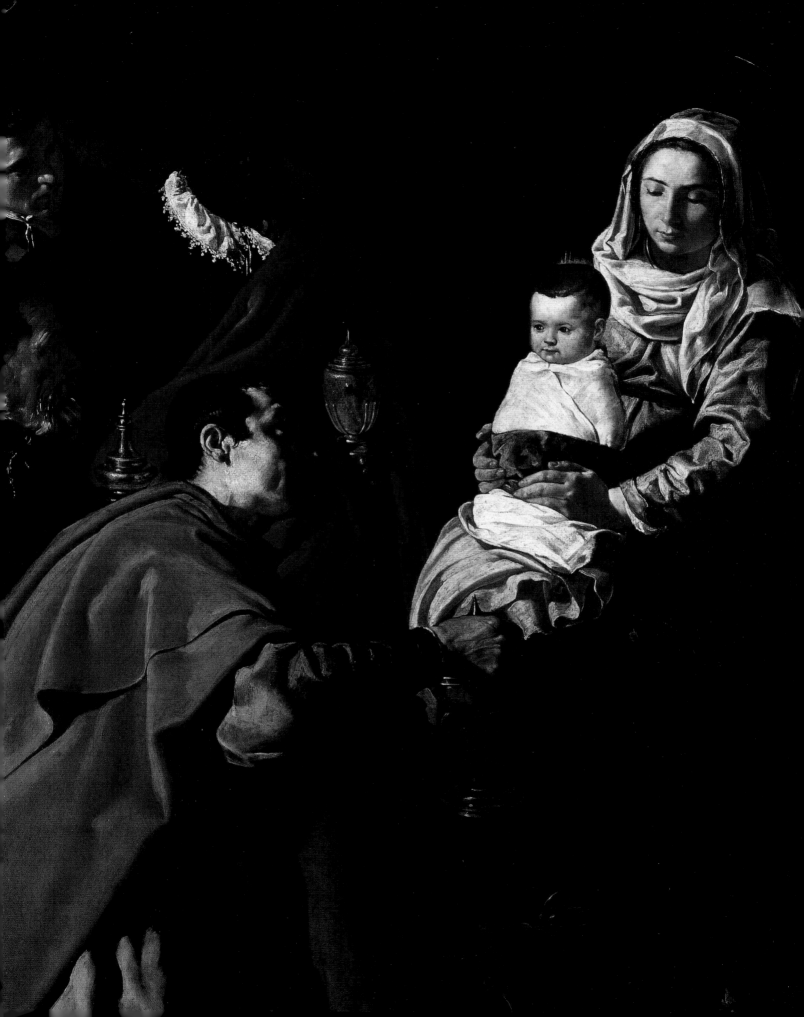

XVIII THE ADORATION OF THE MAGI

Luke recounts how the shepherds came to worship the Christ Child. Matthew, the other Evangelist of the Nativity, focuses on the Magi. Whether they were astrologers and by definition wise men, or actual kings, they were people of power. And they came from afar, from some unspecified Eastern land that drew no love from the Judeans. What factual basis is there to the oral tradition of Matthew's account? There is no easy answer to this, but there is a highly symbolic significance to their presence here: Jesus came for all men of all nations.

Only in the seventh century were the Magi given the names Melchior (in the fifteenth century, he was said to be Caucasian), Balthazar (the African), and Caspar (the Asian). Yet already in the Gospel according to Matthew, we learn that, "The sight of the star filled them with delight, and going into the house they saw the child with his mother Mary, and falling to their knees they did him homage. Then, opening their treasures, they offered him gifts of gold and frankincense and myrrh (Matt. 2:10–11)." These are well-known symbols: gold for the king, frankincense for God, and myrrh that was used for embalming corpses awaiting resurrection. There is a striking—and indeed deliberate—contrast between these highly symbolic gifts and the humility of those who received them and who were to remain destitute and threatened once the Magi had gone on their way.

Diego Velázquez, *Adoration of the Magi* (detail), 1619. Museo del Prado, Madrid.

Masaccio, *Madonna and Child* (detail), c. 1426. Galleria degli Uffizi, Florence.

Motherhood

A new mother. Moved by this new little life, she wonders about his future. About the education he will receive. Painters and sculptors have provided countless interpretations, illustrating all the episodes recounted by Luke and Matthew. Yet they tend to overlook the fact that Mary's life in Nazareth was that of a modest mother, taken up with household chores. They were less concerned with daily reality than with the aura of divinity. Their quest is our joy and hope.

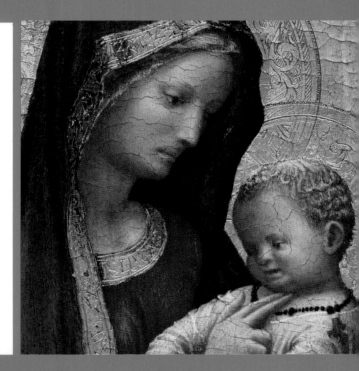

XIX VIRGIN AND CHILD

The caring way the Virgin behaves toward Jesus, her attentiveness and preoccupations are probably no different from those of any mother. Artists have explored this relationship in depth through the theme of the Virgin and Child. This sober image of Mary and Jesus, dating to the third century, in the catacombs of Saint Priscilla is virtually the only testimony to Marian devotion in Rome. Some have suggested that the woman holding Jesus in her arms represents the early church. Her anxious demeanor is an accurate reflection of the sentiments of Christians in Rome at that time. Yet one thing is sure: veneration of Mary flourished much more in the East (in Byzantium and Alexandria) than to the west of the Mediterranean. The vast majority of Marian feast days come from the East, including the Annunciation (March 25) and the Assumption (August 15), the latter being extended around the year 600 by decree of the Byzantine emperor, Maurice, to the whole of the territory under his rule.

Mother and Child (detail), 290. Cubiculum of Velatio, Catacombs of Saint Priscilla, Rome.

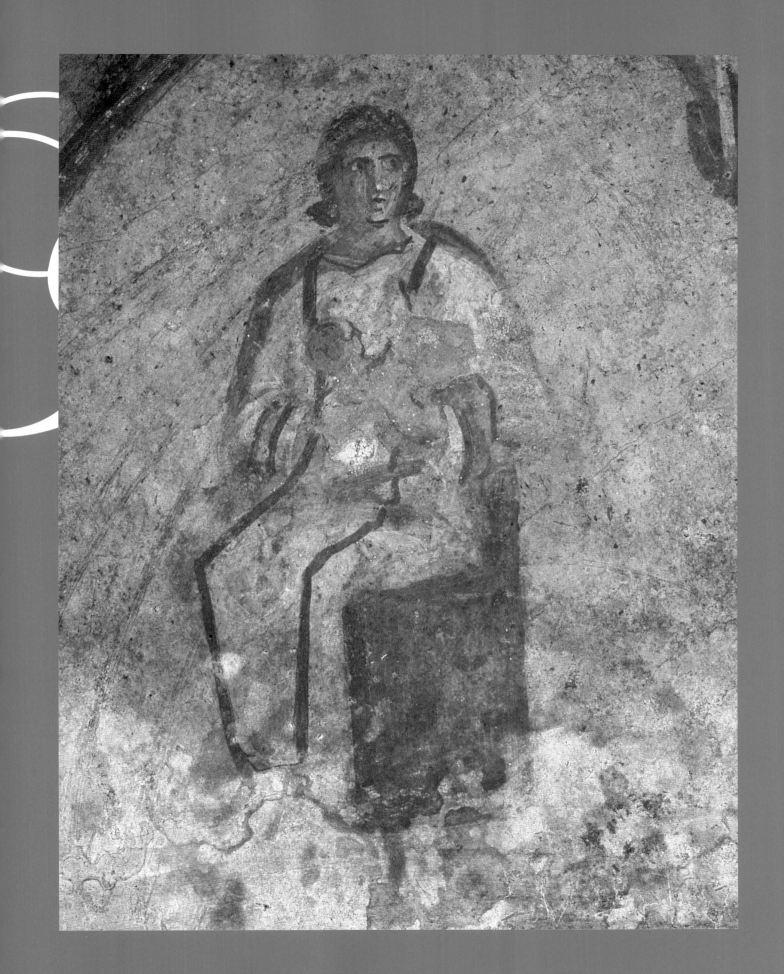

XX MARY NURSING

The Gospel according to John declares that, "The Word became flesh" (John 1:14); Jesus was both man and God. Like all babies, he needed others to help him grow and evolve—beginning with his mother.

In the early centuries, it was rare to find a representation of the Virgin nursing Jesus at her breast. This was partly because some refused to believe that Jesus was a real child, considering him to be like an angel. In 431, the Council of Ephesus, composed almost exclusively of delegates from the East, proclaimed Mary "Theotokos" (Mother of God), while she had previously been considered only as "Christotokos" (Mother of Jesus). This was a means of reasserting the dogma of the Incarnation. Yet it was mainly during the Middle Ages that belief in the Incarnation took hold and Mary was shown breastfeeding.

Jan van Eyck, *Suckling Madonna Enthroned*, 1435–40. Städelsches Kunstinstitut, Frankfurt am Main.

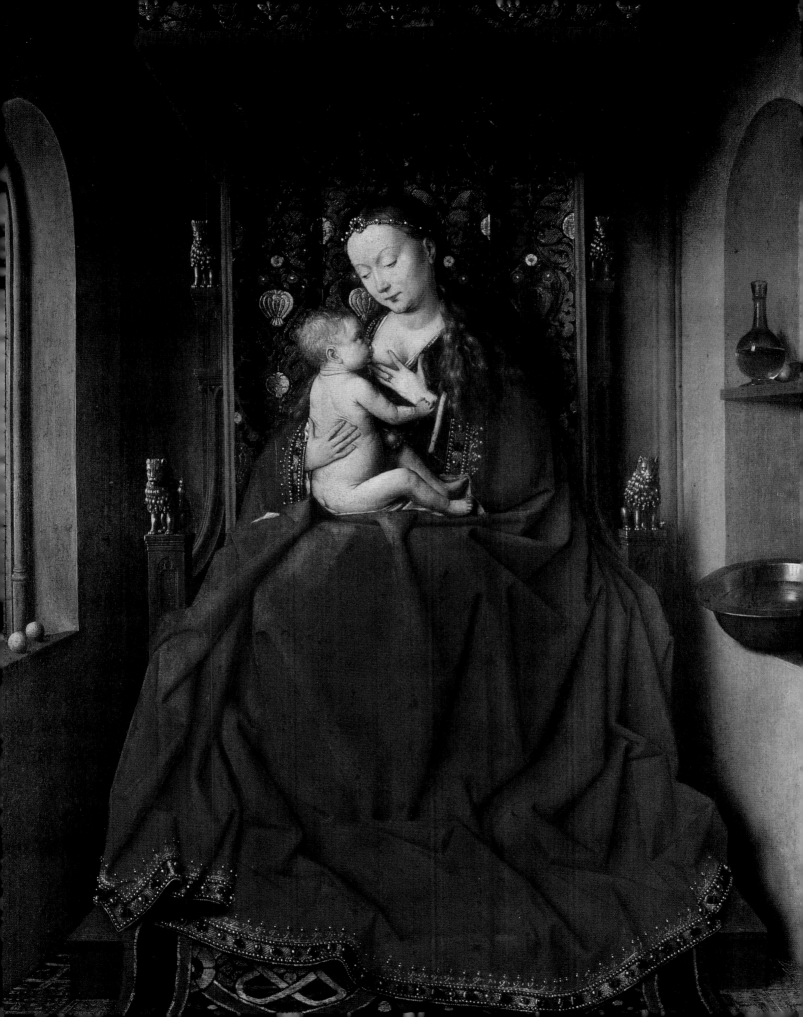

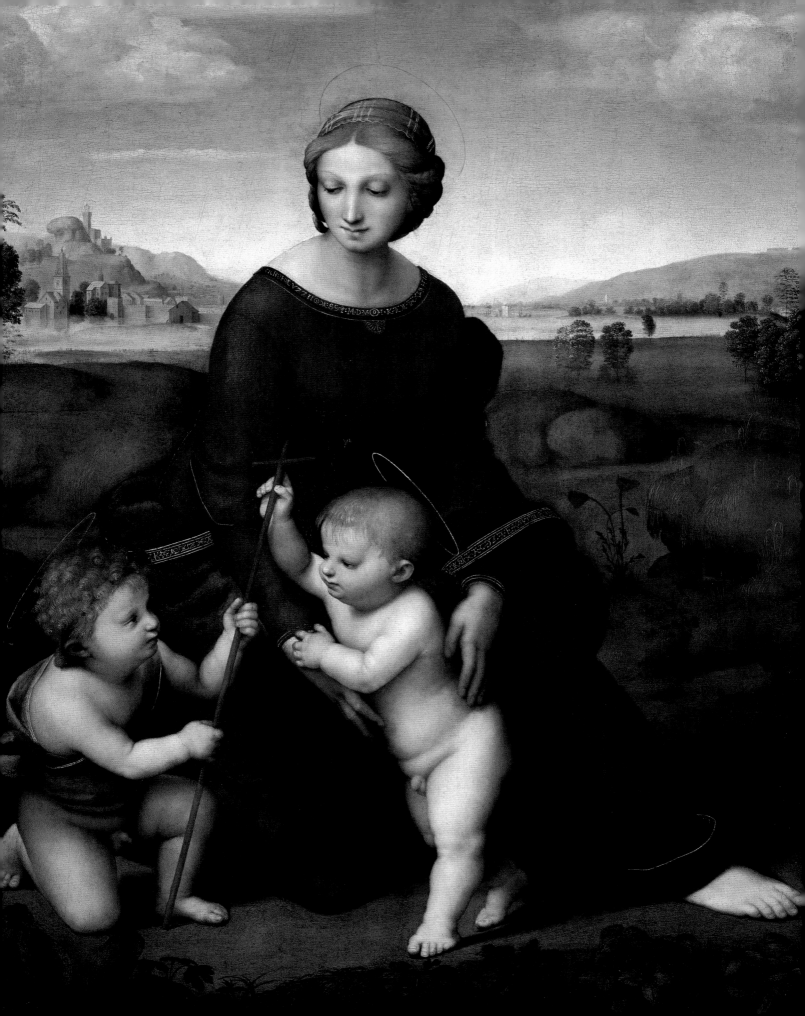

As the child grew, Mary became concerned for his future. The beautiful facial expression in Bellini's painting (p. 75) conveys her meditative state.

It is quite rare to find a representation of Baby Jesus that reveals his genitalia. This could be a reflection of the difficulty some have in believing in the Incarnation. Yet a large number of works show Jesus as a child with a cross (as is the case here with John the Baptist). Mary's face bears an expression of prayerful melancholy.

John the Baptist is shown kneeling, thus emphasizing his inferiority to the Lord Jesus, in the same way that the Evangelists took pains to stress this subordination. Yet Raphael's art comes into its own in the delicate nuances in the facial expressions and flesh tones of the babies.

While the painting from Donatello's studio (p. 74) is strongly realist in its portrayal of a child sucking his fingers just like any little boy of his age, many prefer the magnificent canvasses of Botticelli (p. 77) or Bellini (p. 75) that show a little God respectively wise and administering blessings.

Raphael, *Madonna of the Meadows (Madonna del Belvedere)*, 1505–06. Kunsthistorisches Museum, Vienna.

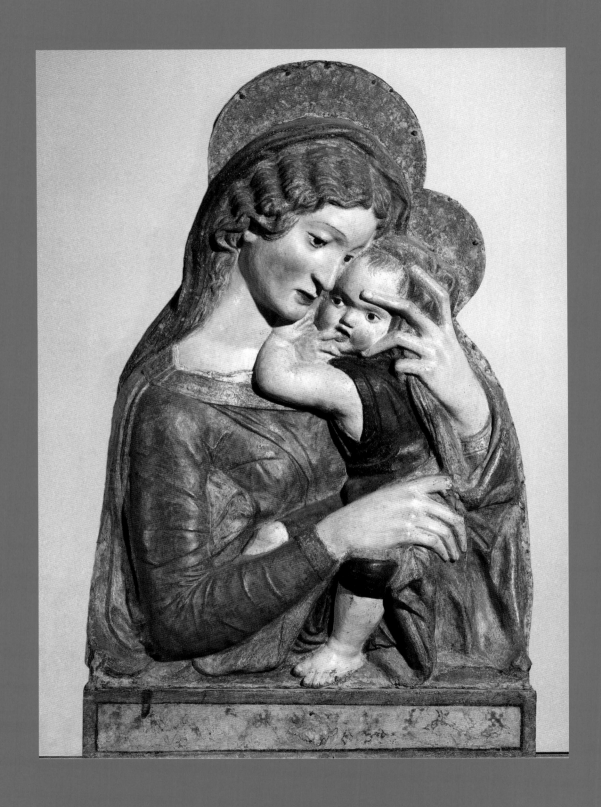

After Donatello, *Virgin and Child* or *Madonna of Verona*, 1460. Musée du Louvre, Paris.
Facing page: Giovanni Bellini, *Madonna with Blessing Child* (detail), 1475. Gallerie dell'Accademia, Venice.

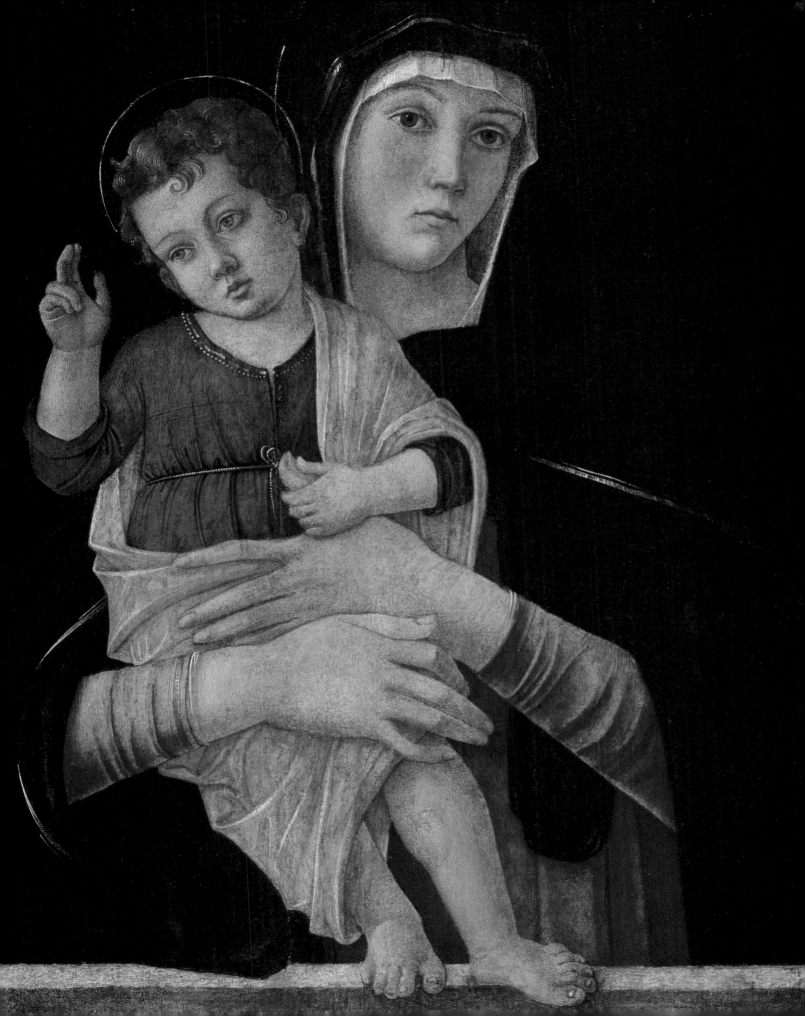

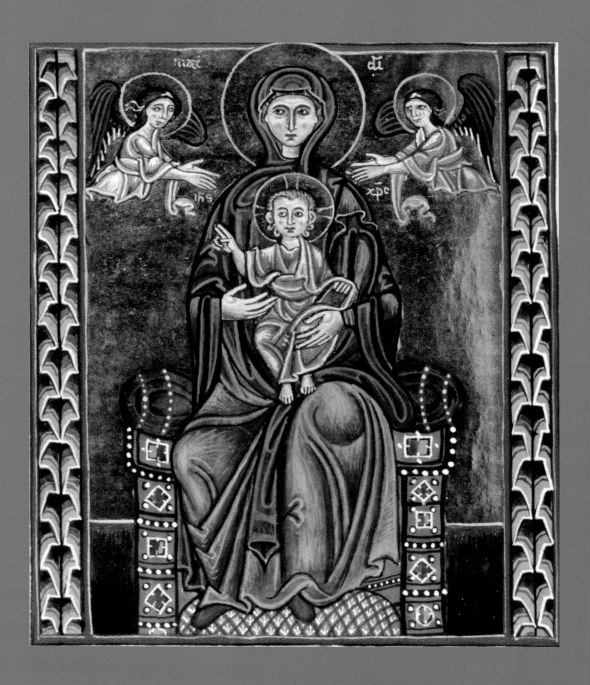

Madonna and Child, copy of a Byzantine mosaic, Queen Melisande's Psalter, 1139. National Gallery, London.
Facing page: Sandro Botticelli, *Madonna and Child with Five Angels* or *Madonna of the Magnificat* (detail), 1481.
Galleria degli Uffizi, Florence.

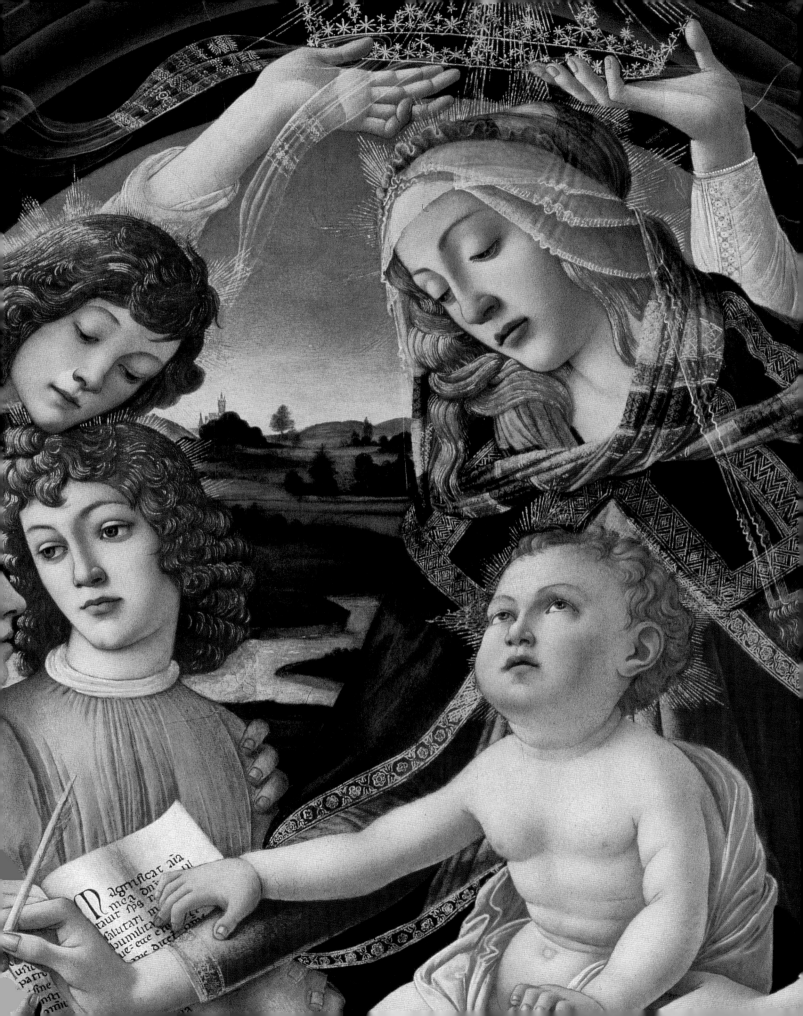

XXII THE BLACK MADONNA

The cult of "Theotokos" (Mother of God) inspired a large number of statues hewn from a single block of wood. Often smaller than life-sized and black in color, these works showed Mary seated on a throne (as a queen) with the Infant Jesus on her lap. Found mainly in France and in Spain, the origin of these "Black Madonnas" or "Madonnas in Majesty" (that were sometimes adorned with various colors as is the case here) remains a mystery. Yet they are reminiscent of the Song of Songs:

> "I am black but lovely, daughters of Jerusalem. . .
> Take no notice of my dark colouring, it is the sun that has burnt me" (Song 1:5–6).

Black Madonna, 1150. Abbey-church of Saint Léger and Saint-André, Meymac.

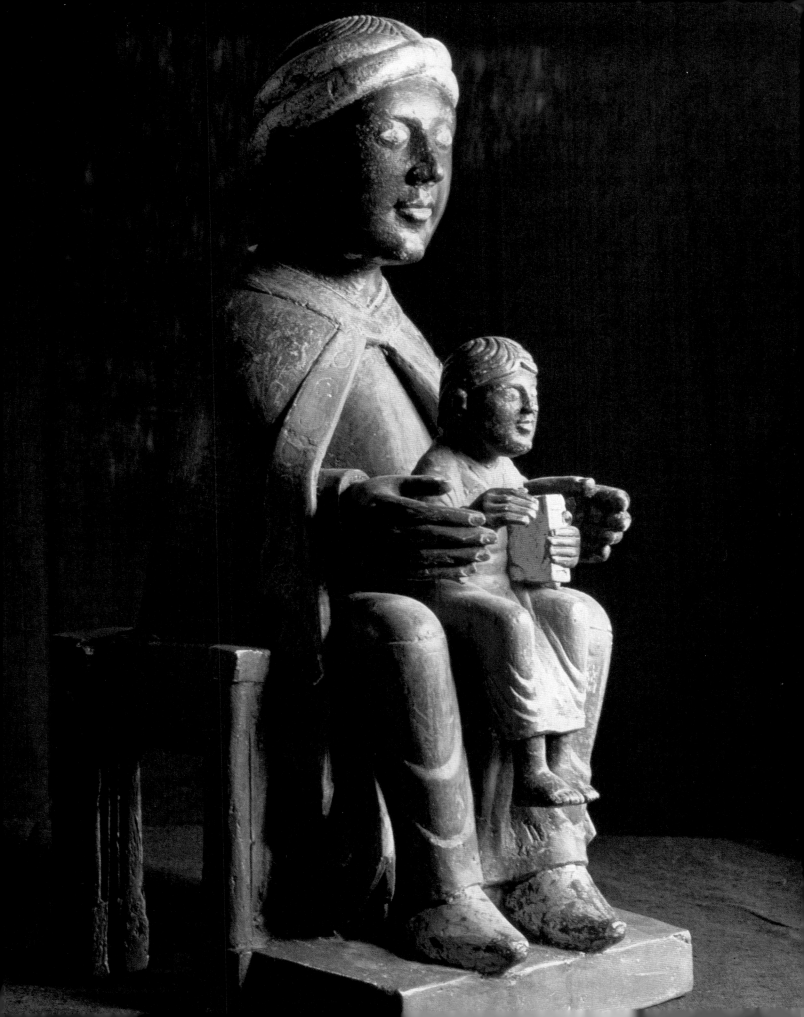

XXIII CIRCUMCISION

Jesus was circumcised eight days after his birth in accordance with the Mosaic Law. This act, whose practice (usually at the onset of puberty) was widespread among various peoples at the time, took on a particular significance for Hebrews as a mark of their covenant with God.

The blood that flows is the "blood of the covenant" for the mission that had been entrusted unto mankind since Genesis: to strive for a better world. It may seem incongruous that Jesus was subjected to a ritual that symbolized a covenant with God—namely Himself. Yet this was a sign of his belonging to the Jewish people and of his solidarity with them. Of course, this painting is not—nor does it claim to be—an accurate reconstruction of history: the Renaissance artists sought rather to establish a link between antiquity and Christianity, using a contemporary architectural setting for ancient scenes. In Mazzolino's painting, Mary stands to the left away from the action. She is just part of the crowd, as if the Christ Child had already been taken from her. Yet it is to her that Baby Jesus stretches out his arm.

Ludovico Mazzolino, *Circumcision of Christ* (detail), 1526. Kunsthistorisches Museum, Vienna.

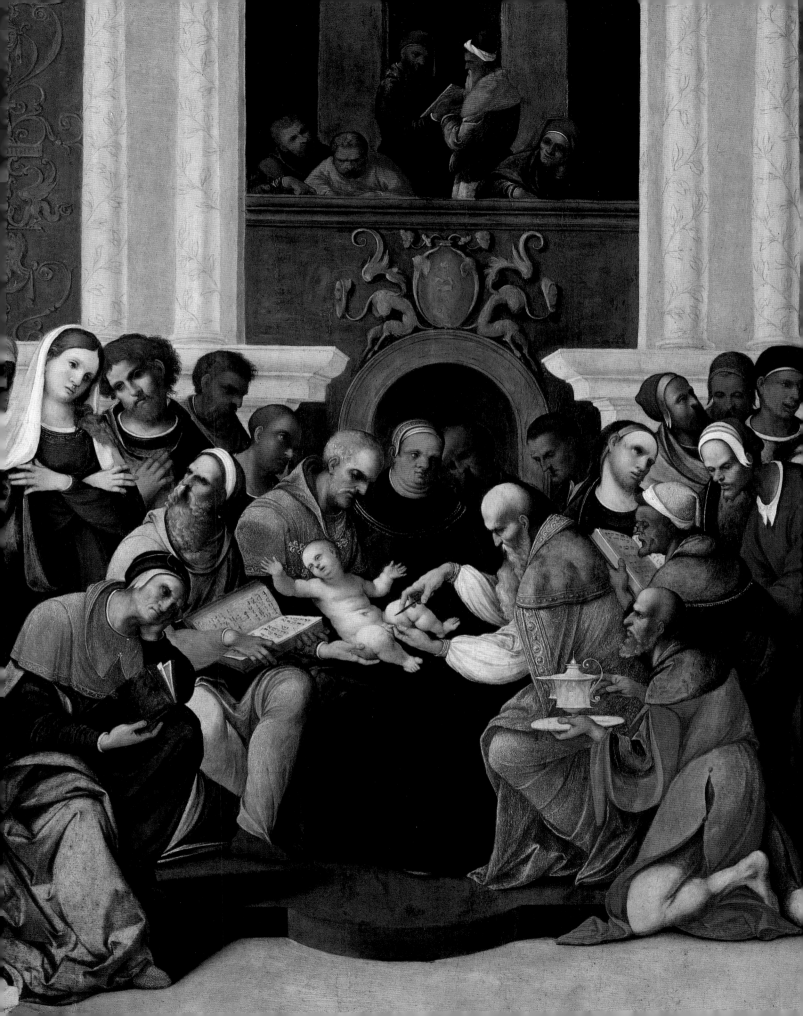

XXIV THE PRESENTATION OF JESUS AT THE TEMPLE

All mothers were obliged to purify themselves after giving birth (forty days for a boy and twice that for a girl). In the Gospel according to Luke—the only of the Evangelists to mention this ritual—the purification ceremony coincided with the presentation of Jesus at the Temple. We may ask ourselves why Mary, the embodiment of purity itself, needed to be purified. It was obviously to stress that she shared in the human condition.

At the Temple, Mary presented Jesus to an old man named Simeon, who regularly worshipped there. She thus offered up the child to man and God in a single gesture. Luke describes how Simeon, inspired by the Holy Spirit, declared that Jesus was born "a light of revelation" (Luke 2:32), prophesying to Mary that: "a sword will pierce your soul" (Luke 2:35). But remember that this declaration from the Gospel according to Luke was made several decades after the Crucifixion.

Simeon himself was neither a priest nor a Levite, but a simple, God-fearing man. As with the shepherds, called to worship at the Nativity, this goes to show how Jesus, of lowly birth among the lowly, was recognized at the Temple only by those without authority. Giotto seems to have misunderstood this point. True to style, he portrays both Jesus and Simeon encircled with haloes.

Simeon was not alone. An old woman was with him in the Temple. Her name was Anna (shown on the far right in Giotto's painting), a prophetess by trade, which was quite common in Judea at that time. At the age of eighty-four, she was to go on to spread the news of the Christ Child "to all who looked forward to the deliverance of Jerusalem" (Luke 2:38). This would be one more proclamation of the birth of Christ—between the visit of the shepherds and that of the Magi.

Giotto, *Presentation of Christ at the Temple*, 1304–06. Cappella Scrovegni (Arena Chapel), Padua.

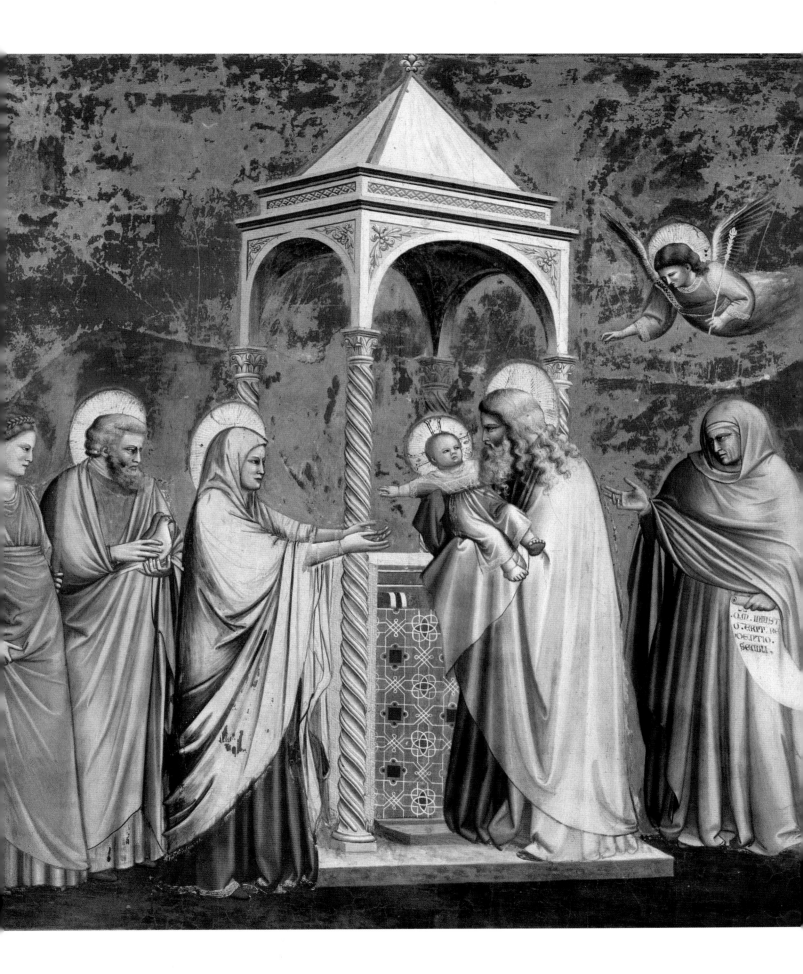

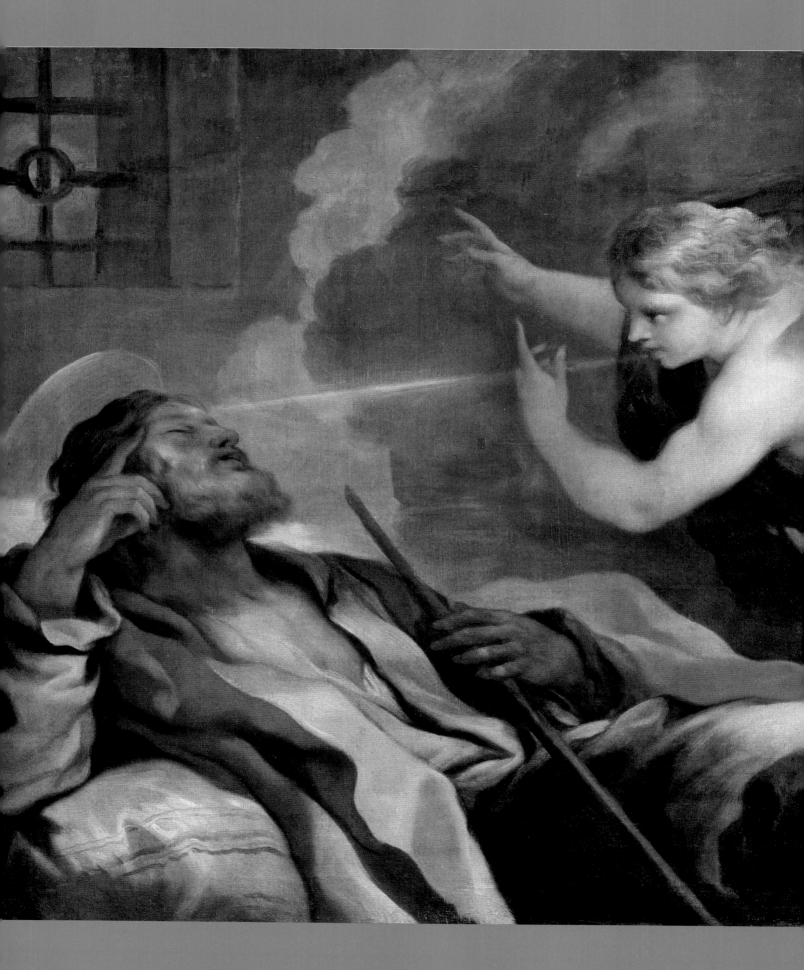

"Suddenly the angel of the Lord appeared to Joseph in a dream and said, 'Get up, take the child and his mother with you, and escape into Egypt, and stay there until I tell you, because Herod intends to search for the child and do away with him" (Matt. 2:13).

Matthew speaks of a terrible drama, a source of anxiety, which is illustrated in Luca Giordano's *Joseph's Dream*. He goes on to explain that Joseph was given three warnings, but this one is alarming. "The angel of the Lord" warns Joseph that Herod, the tyrant of Jerusalem, is seeking to kill the Christ Child. In fact, the Magi had spoken to Herod of a king of the Jews—and therefore a future rival—when they were looking for the newborn babe. Thus, "in Bethlehem and its surrounding district he had all the male children killed who were two years old or less" (Matt. 2:16). This "Massacre of the Innocents" is mentioned only in the Gospel according to Matthew. The notion of flight evokes the fate of millions of refugees over the centuries. For the Evangelists, it was a way of recalling the Egyptian Exodus of the Jewish people, while emphasizing once again the dark and difficult conditions that prevailed during Jesus' childhood. This is far removed from the rosy representations of Christ's early years. Indeed, it is rather a humbling experience for the Son of God, for Mary, and for Joseph—to whom, oddly enough, Dürer fails to give a halo (p. 86). Jacquemart Hesdin's miniature (p. 87) gives little inkling of the dramatic nature of the flight, despite showing the Holy Family forced to seek refuge in a cave. Interestingly, the sea and port shown above them seem to represent a world of riches to which the couple is denied access. In the Bible, the sea often has negative connotations, the lair of diabolical powers.

Luca Giordano, *Joseph's Dream* (detail), 1680. Kunsthistorisches Museum, Vienna.

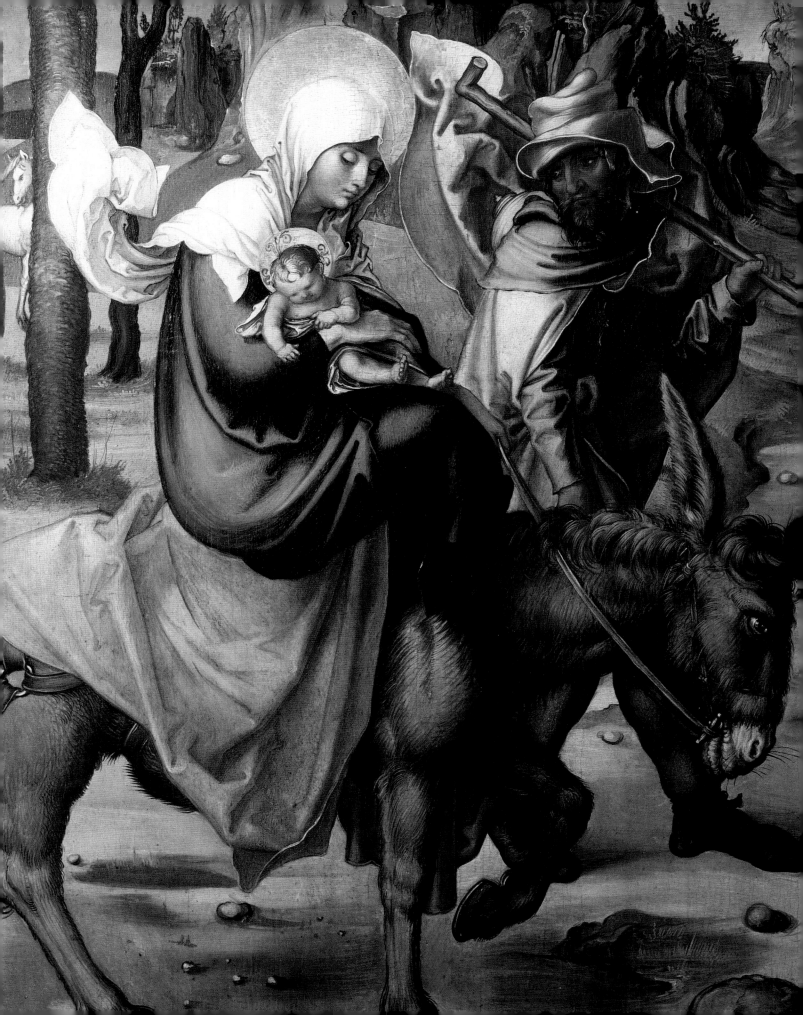

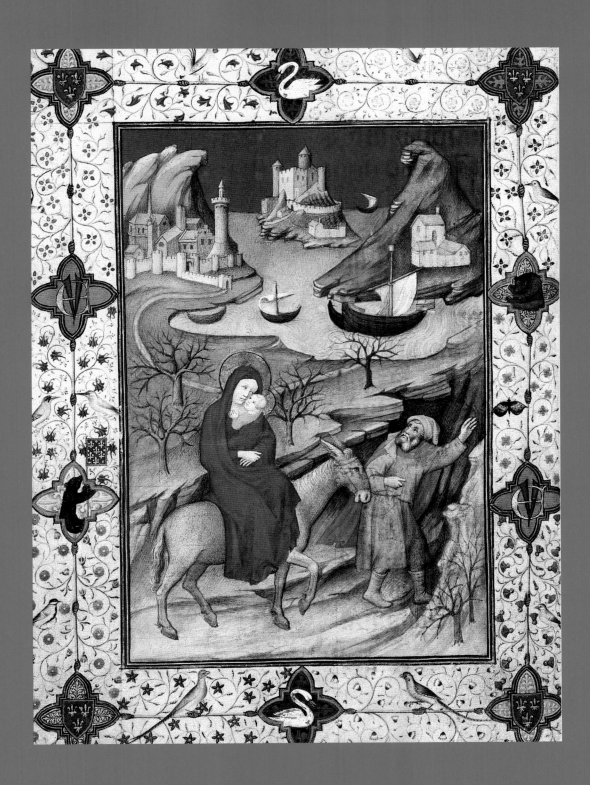

Jacquemart Hesdin, *The Flight into Egypt* (detail), 1408–09. Bibliothèque Royale, Brussels.
Facing page: Albrecht Dürer, *The Flight into Egypt* (detail), 1495. Gemäldegalerie, Dresden.

Matthew, who is the only Evangelist to mention the Flight into Egypt, tells us nothing about how the family fared in Pharaoh's land. Nicolas Poussin, however, depicts a nomadic existence, relying on aid from others. This could also be a portrayal of poverty, were it not for the fact that Mary is so splendidly attired. She is radiant at the painting's center, while Joseph is shown in shadow, barely visible. Yet Matthew does describe how the angel reappeared "in a dream to Joseph in Egypt and said 'Get up, take the child and his mother with you and go back to the land of Israel, for those who wanted to kill the child are dead'" (Matt. 2:20).

Caravaggio depicts the angel (p. 90) as a superb, dazzling being: the divine messenger stands at the center of the painting, a justifiable position for the Word of God. Mary and Joseph trust in the angel's instructions. They have faith.

Nicolas Poussin, *The Holy Family in Egypt* (detail), 1655–57.
Hermitage Museum, Saint Petersburg.

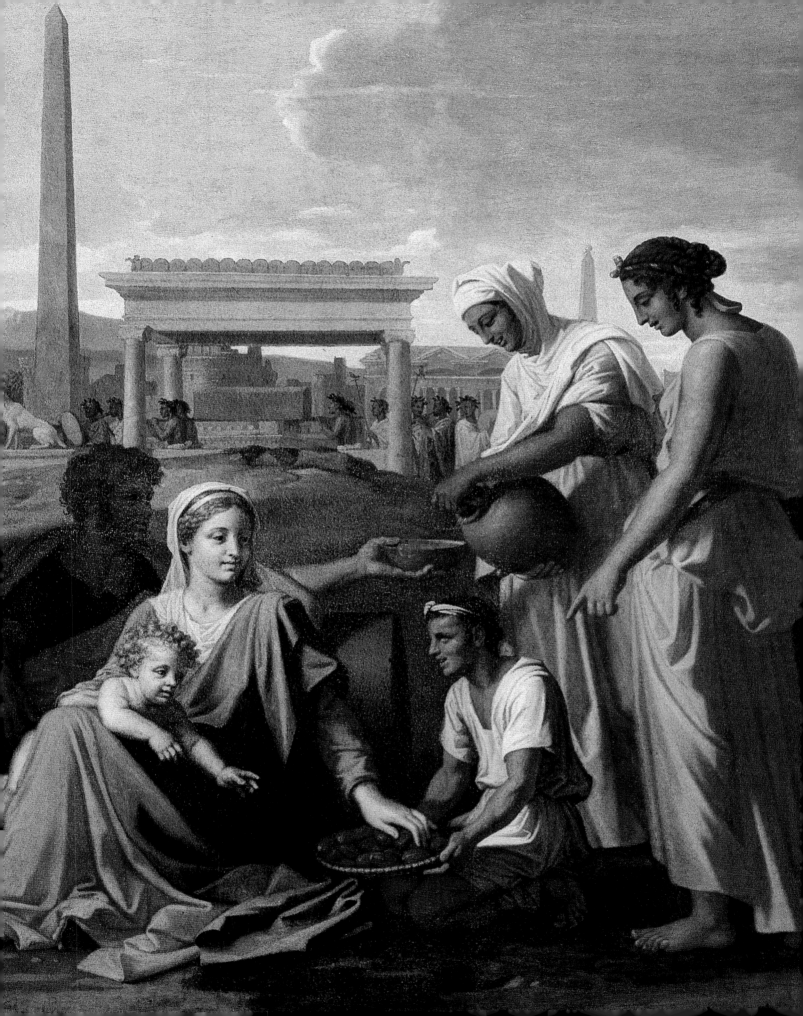

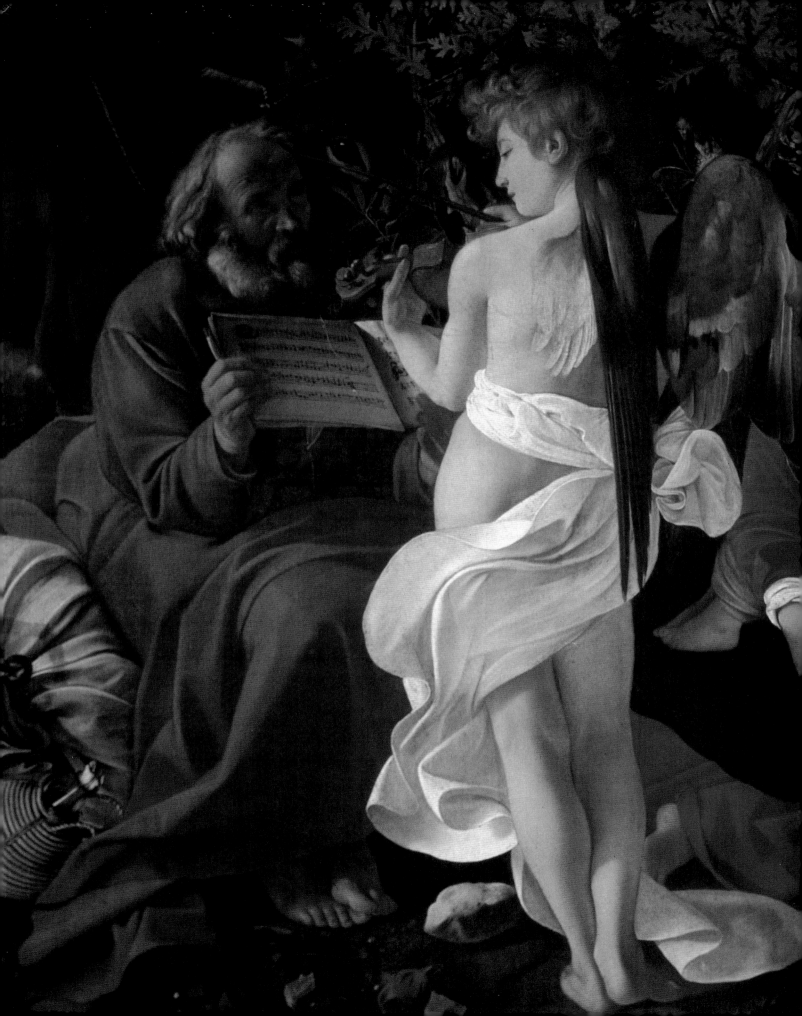

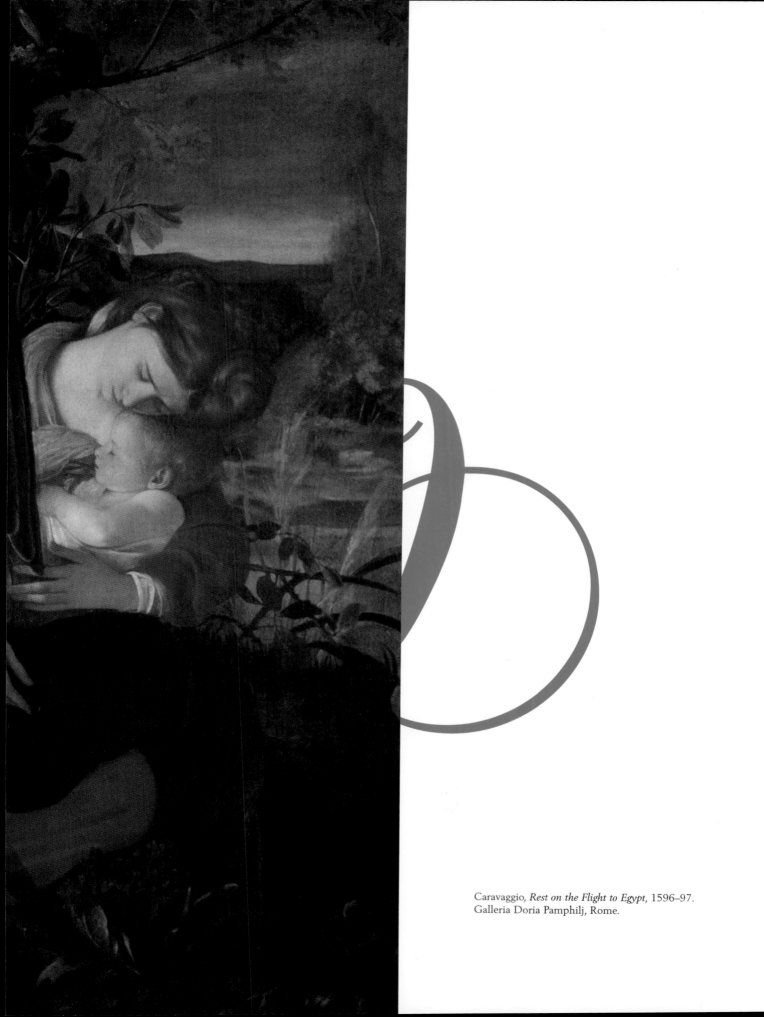

Caravaggio, *Rest on the Flight to Egypt*, 1596–97.
Galleria Doria Pamphilj, Rome.

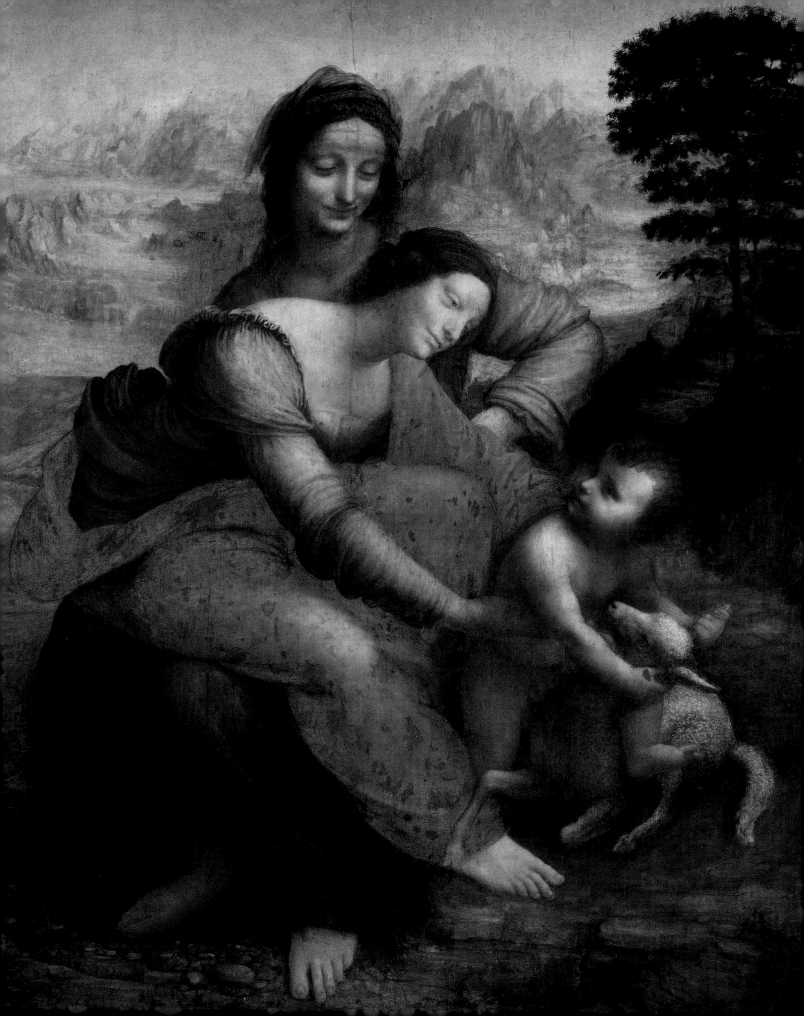

On their return, family life fell back into its routine, though the Gospels tell us nothing about Mary's daily life. Saint Anna occupies the top of the pyramid-shaped composition, a favorite device of Leonardo da Vinci. The presence of the lamb—a frequent motif in images of Jesus as a child—is a reference to the words of John the Baptist when Jesus came to be baptized by him on the banks of the River Jordan: "Look, there is the lamb of God" (John 1:29). Often offered in sacrifice at the Temple of Jerusalem, the lamb is a symbol of the innocent victim, foreshadowing the death of Christ on the Cross.

Caravaggio's painting (p. 95), which also features Saint Anna, exudes an exceptional dramatic force coupled with a striking symbolism. Mary's foot, beneath that of Jesus, crushes the serpent that has come to represent the devil. Ever since the early centuries, the church fathers had set Eve against Mary: Mary serves to obliterate the action of the primeval woman who plunged the world into misery by lending ear to a snake. The image of Mary trampling the serpent underfoot is widespread.

Leonardo da Vinci, *The Virgin and Child with Saint Anna*, 1501. Musée du Louvre, Paris.
Following pages, left: Bronzino, *The Holy Family with Saint Anna and Infant John the Baptist*, 1550. Musée du Louvre, Paris.
Following pages, right: Caravaggio, *Madonna dei Palafrenieri* or *Madonna with the Serpent*, 1605–06. Galleria Borghese, Rome.

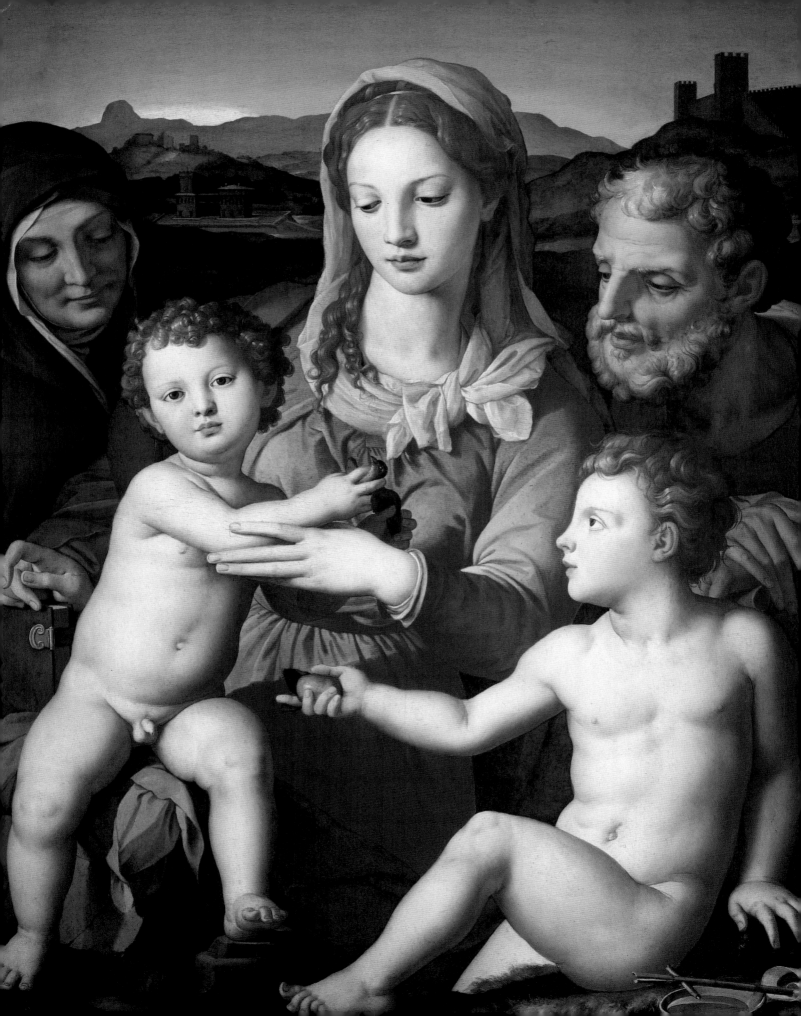

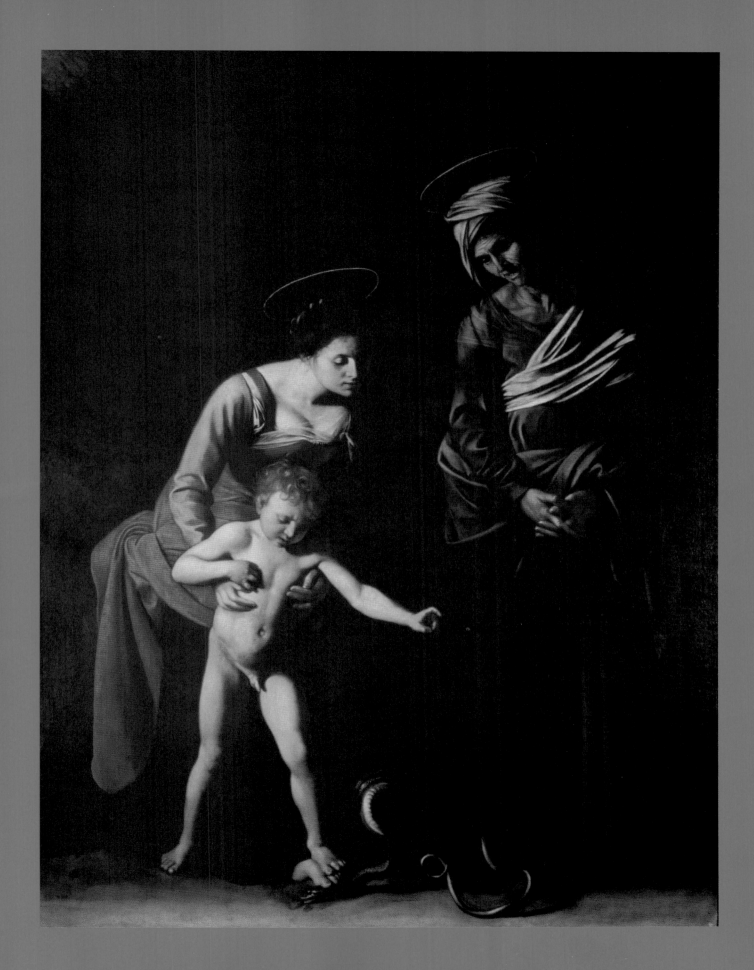

XXVIII A MOTHER'S ANXIETY

Anxiety and anguish are already apparent. Fervent believers, the family made a pilgrimage to Jerusalem along with tens of thousands of others for the Feast of the Passover, which commemorates the Hebrew people's return from Egypt. It meant a long walk for the Galileans.

It was here that Jesus, perhaps almost thirteen years old at the time, lingered behind to talk to the "teachers," who often on a voluntary basis provided commentaries on the Holy Scriptures in the Temple. When his parents failed to find him in the crowd of pilgrims, they went back to Jerusalem looking for him everywhere. "It happened that, three days later, they found him in the Temple, sitting among the teachers, listening to them, and asking them questions" (Luke 2:45–46). Still transfixed with fear, Mary was secretly thrilled with joy at finding Jesus but said to him "My child, why have you done this to us? See how worried your father and I have been, looking for you." (Luke 2:48). Jesus' immediate response was "Why were you looking for me? Did you not know that I must be in my Father's house?" (Luke 2:49). Luke is telling us here that this marks the beginning of a parting that will bring with it suffering, that Mary and Jesus will go their separate ways, even if they share the same faith.

Simone Martini, *Christ Discovered in the Temple,* 1342. Walker Art Gallery, Liverpool.

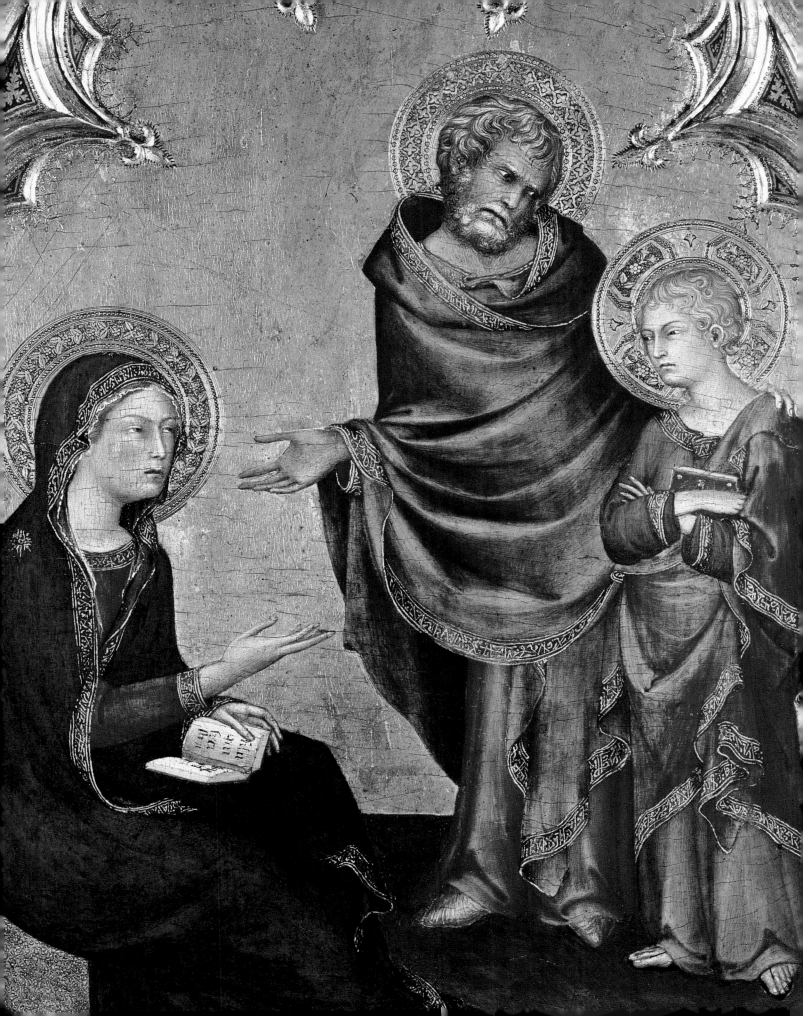

XXIX FAMILY AND FRIENDS

In Nazareth, Mary, Joseph, and Jesus did not live in isolation as is often portrayed.
In this small village with its cramped dwellings, where doors were always open, neighbors,
siblings, and cousins would go from house to house in a constant flurry of laughter, play,
and quarreling. It was lively. The sculpture shown here is therefore a rare image of Mary
and her extended family. Anna gathers together her little world in her arms. Mary,
at the center, is wearing a crown and holding Jesus, thronged by a bevy of urchins.

Holy Kinship, 1510. Church of Chavanat.

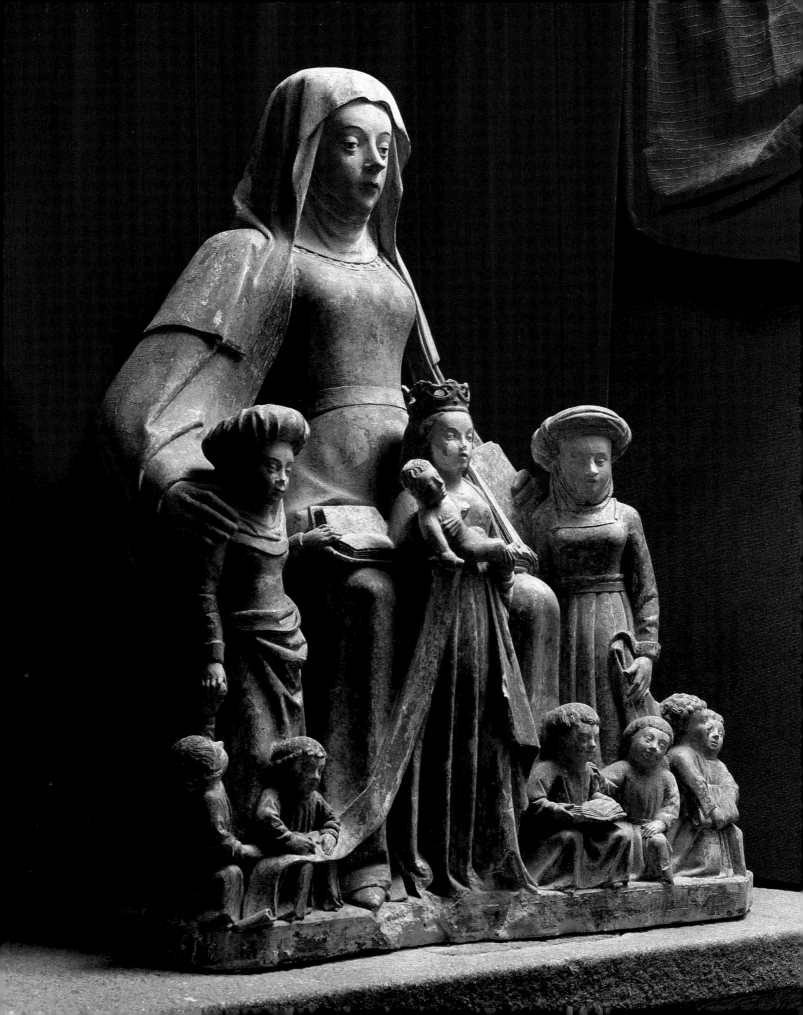

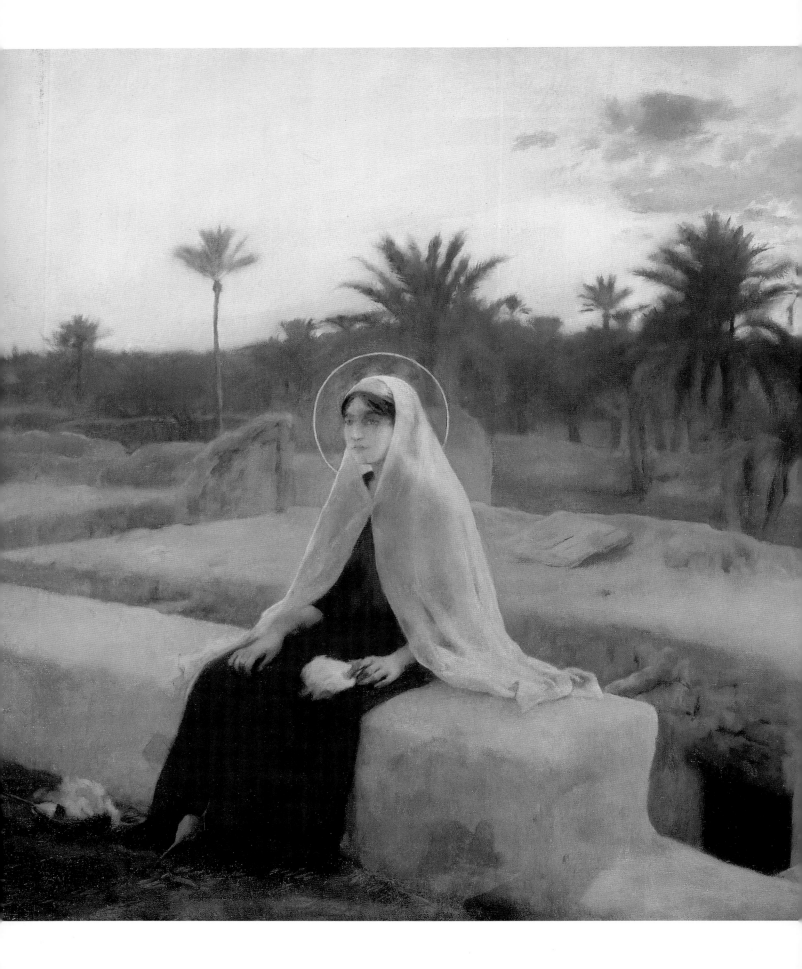

XXX DAILY LIFE

Unlike the artists of the Renaissance, the nineteenth-century painter Paul Leroy took pains to remain "true to life" and to capture "local color." Yet the solitude pictured here was virtually unheard of in the little village of Nazareth. This moving image of Mary seems to be inspired more by North African dwellings and landscapes than those of Nazareth.

Paul Leroy, *Evening in Nazareth* (detail), nineteenth century. Musée des Beaux-Arts, Lille.

XXXI JOSEPH

"And Jesus increased in wisdom, in stature, and in favour with God and with people" (Luke 2:52). Joseph had a hand in his education and training. Childrearing was not only the mother's domain. Joseph taught him how to carve wood and how to raise the walls and terraces of the mud-brick dwellings in Nazareth—a far cry from the marble palaces that so many painters chose as the backdrop for the Holy Family. It was also Joseph who took Jesus to the synagogue three times a week.

Yet the Gospels make no further mention of Joseph after the pilgrimage to the Temple when Jesus was an adolescent. Nor do they tell us about his death, the date of which remains unknown. The artist here shows Joseph being blessed by Jesus, now a full-fledged man who had perhaps already started preaching. This is a rare example of Mary shown as an unobtrusive figure, even though she stands at the center of the painting.

Carlo Maratta, *The Death of Saint Joseph* (detail), 1676. Kunsthistorisches Museum, Vienna.

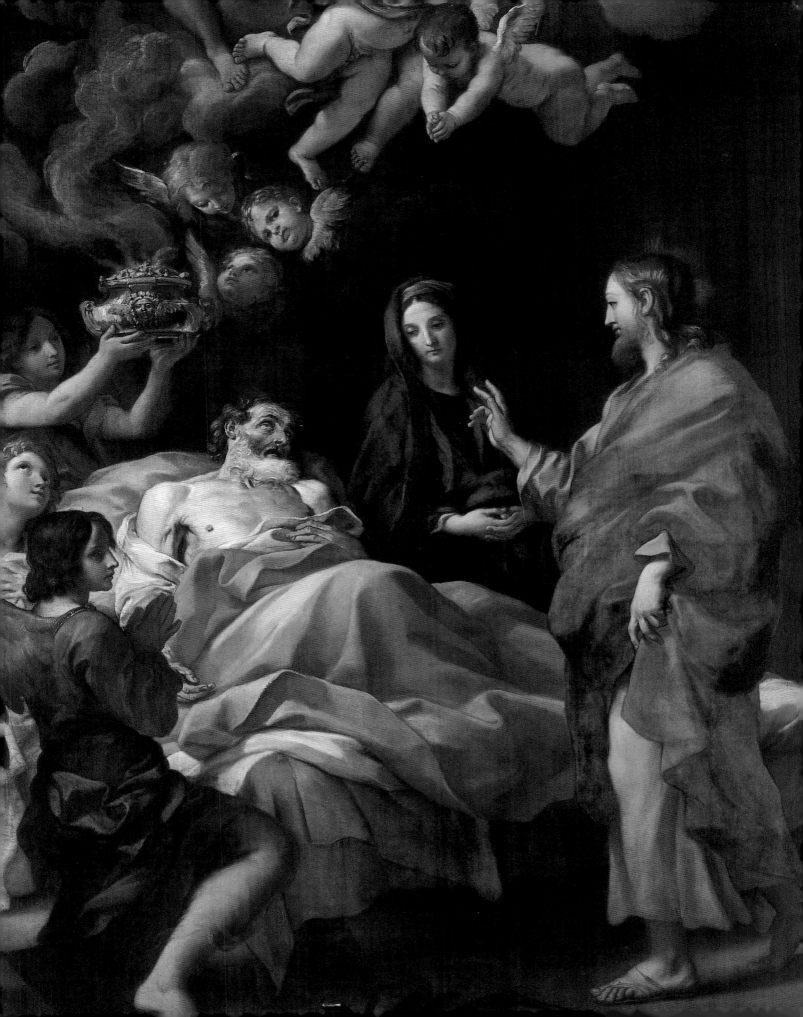

Lamentation of Christ (detail), 1164. Panteleimon Church, Nerezi.

In the Shadow of Jesus

Once Jesus began his mission, Mary remained in the background—as is often a mother's fate. John mentions her only twice: at Cana and at the foot of the Cross. Luke notes that when preaching Jesus "was told, 'Your mother and brothers are standing outside and want to see you.' But he said in answer: 'My mother and my brothers are those who hear the word of God and put it into practice'" (Luke 8:20–21).

Mary's trial had begun, yet the worst was to come: the Cross.

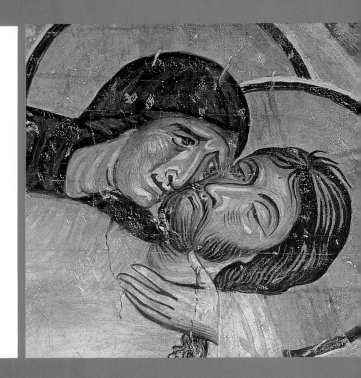

XXXII THE MARRIAGE AT CANA

Jesus and Mary were invited to a wedding in Cana, in Galilee. Seeing that the wine had run out, Mary informed Jesus and told the servants: "Do whatever he tells you" (John 2:5). Jesus commanded them to fill six jars used for ritual purifications, then to draw off some of the water and to take a cup to the host of the feast.

Jesus had turned the water into wine.

The famous miracle at Cana, recounted only by John, is highly symbolic. This "new wine" heralds a new Law, one more strongly grounded in the faith in one God. For Mary, what matters is the complete confidence she has in her son. She puts her full trust in him.

Both Tintoretto and Paolo Veronese (pp. 108–9), with their respective styles, set Mary and Jesus at the heart of the scene, quite ignoring the happy couple. John does the same—unlike most accounts of Christ's miracles, the main recipients of Jesus' act, the newlyweds, are not identified. The bride is totally ignored. John's attention is elsewhere: for him, Mary is the symbol of Israel, whose trust is placed fully in God.

Tintoretto, *The Marriage at Cana* (detail), 1561. Santa Maria della Salute, Venice.
Following pages: Veronese, *The Marriage at Cana*, 1563. Musée du Louvre, Paris.

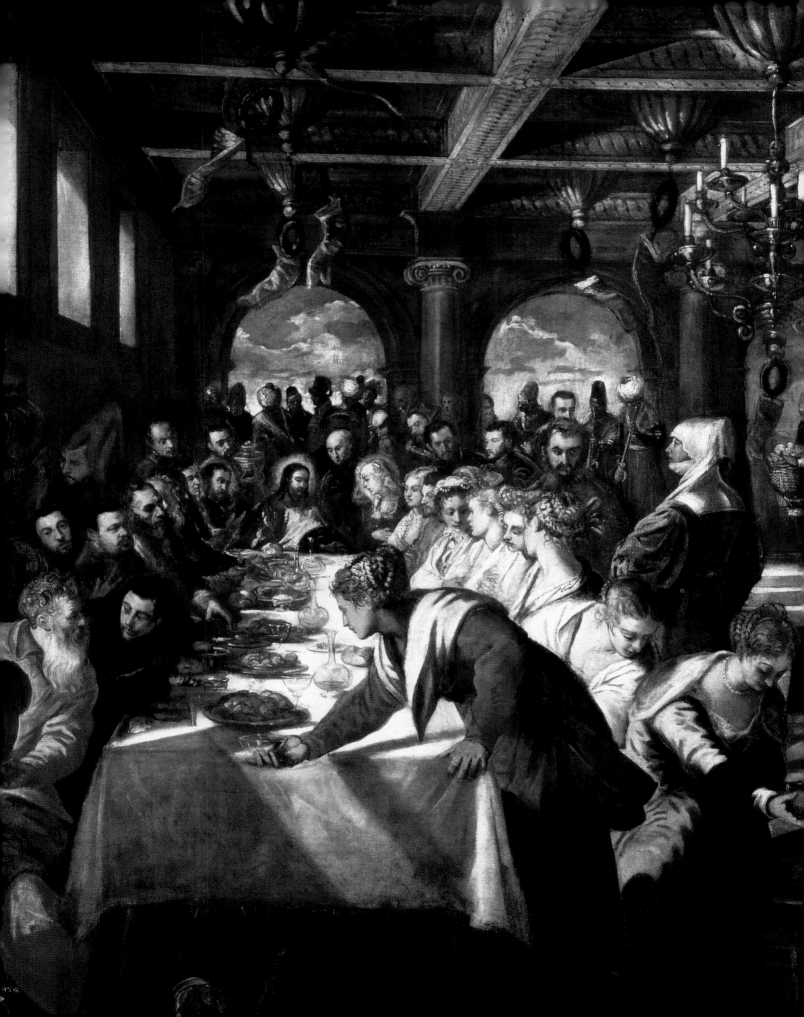

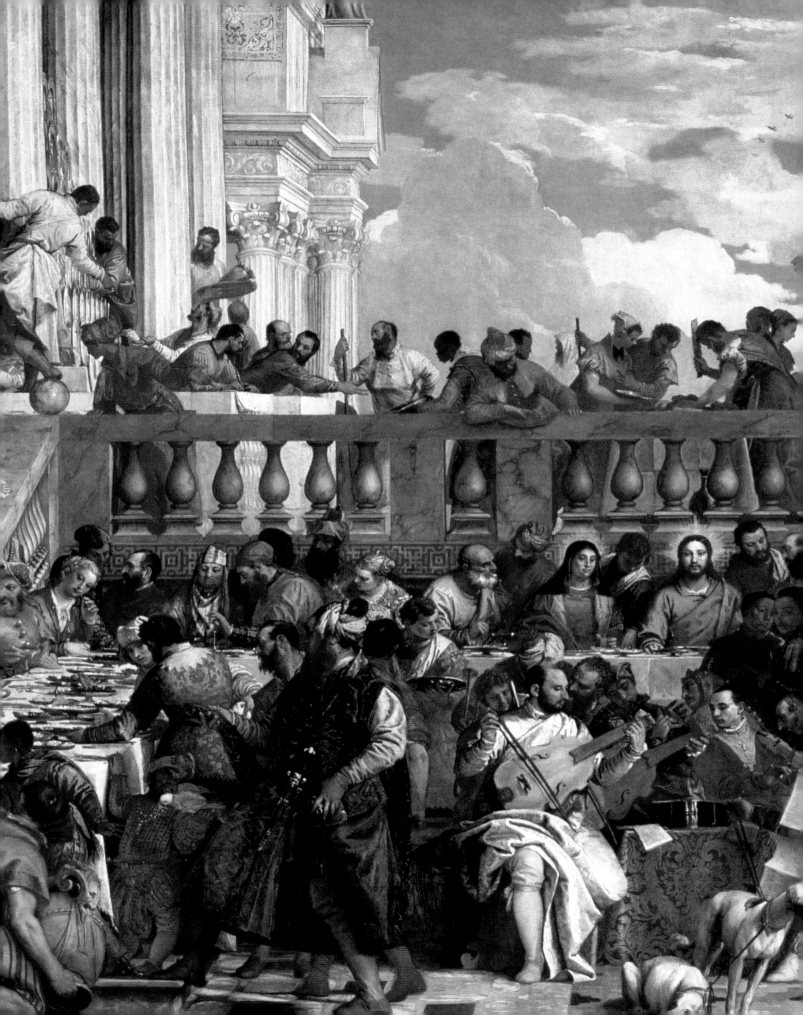

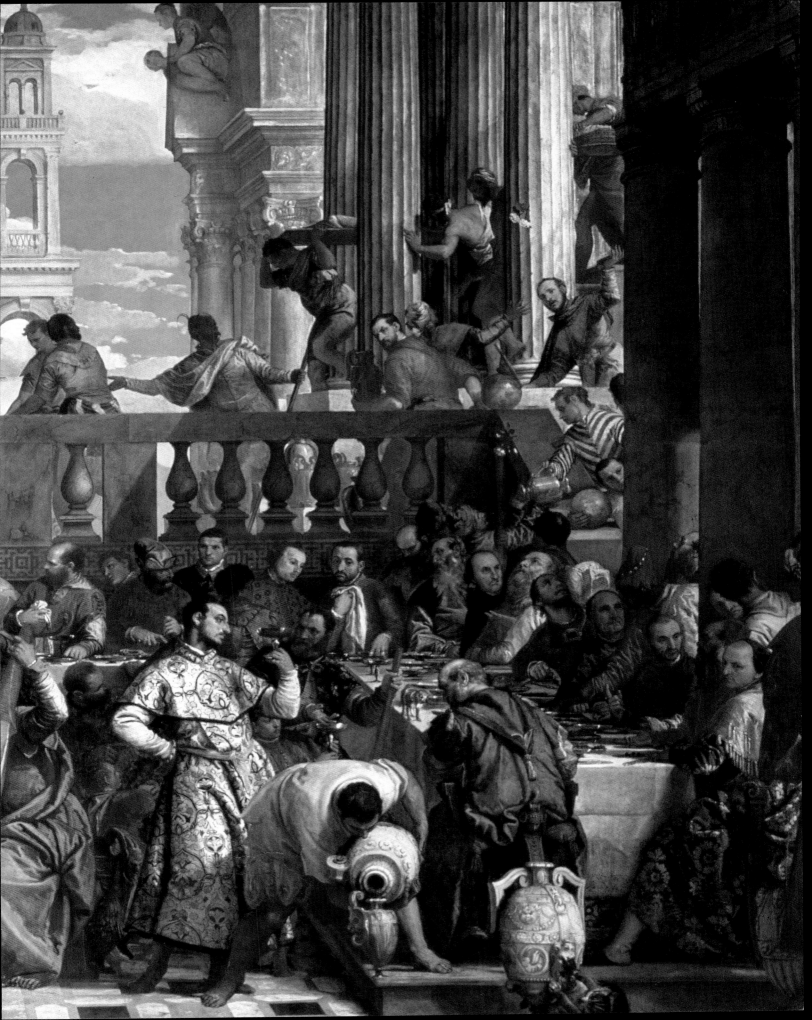

XXXIII JESUS BIDS MARY FAREWELL

As he takes leave of his mother, Jesus starts to bless her. Mary's mind is restless.

Having been brought up in the traditional Jewish faith, Mary raised her child with respect for these beliefs and the strict observance of its rites. And now, here he is challenging them in both word and—she already senses—in deed. This was probably no trivial matter for her, and one that is all too often overlooked.

Gerard David, *Christ Blessing the Virgin Mary* or the *Separation of Christ and Mary*, 1500. Kunstmuseum, Basel.

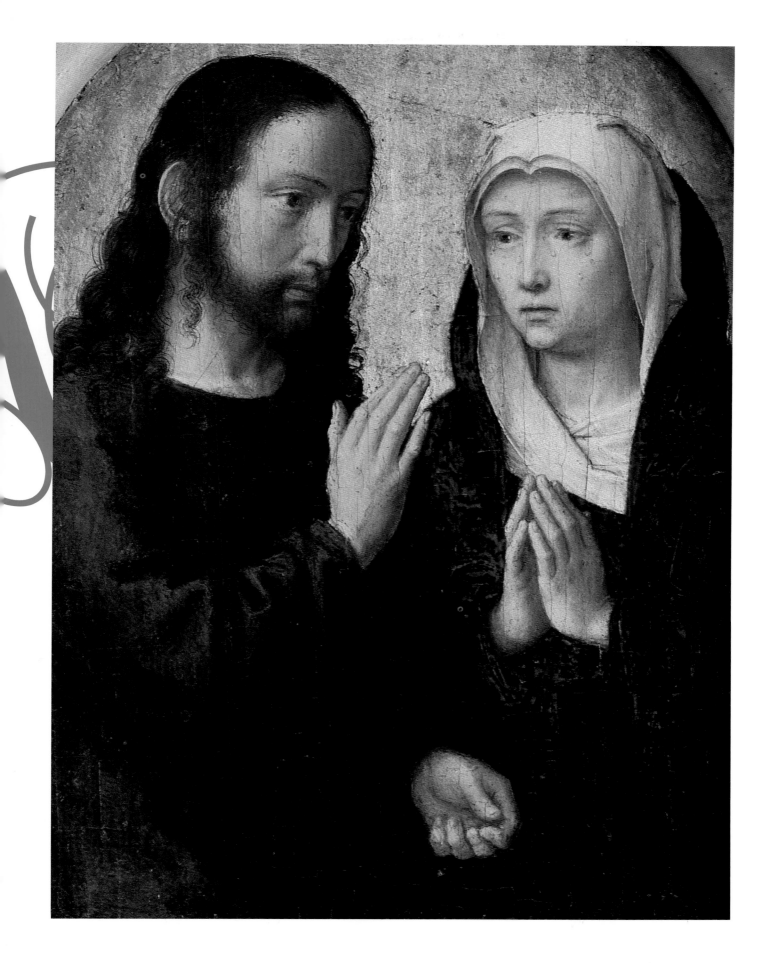

"Love your enemies" (Luke 6:27): Jesus' teachings spoke of love, revealing the face of a God who was neither vengeful nor full of wrath, a God whose power was that of Love, like the father of the prodigal son. Yet he also ruffled some feathers, shocked even, when he lashed out at the Temple of Jerusalem, a sacred place and the very pulse of Israel. He made many enemies and was arrested and sentenced to death.

The hardest trial began with the night before his death. Jesus was to suffer humiliation before being crucified. His clothes were torn, he was whipped, and made to wear a crown of thorns. Fra Angelico's composition is quite bizarre—lacking in realism but highly suggestive. It shows the humiliation cast on Jesus: the subtle crown of thorns, a man spitting. Yet Jesus seems oblivious to this—he is praying—and appears to rise above these insults. Mary is weeping, while Saint Dominic (Fra Angelico was of the Dominican order) sits in meditation.

Fra Angelico, *Mocking of Christ with the Virgin and Saint Dominic*, 1439–45. Monastery of San Marco, Florence.

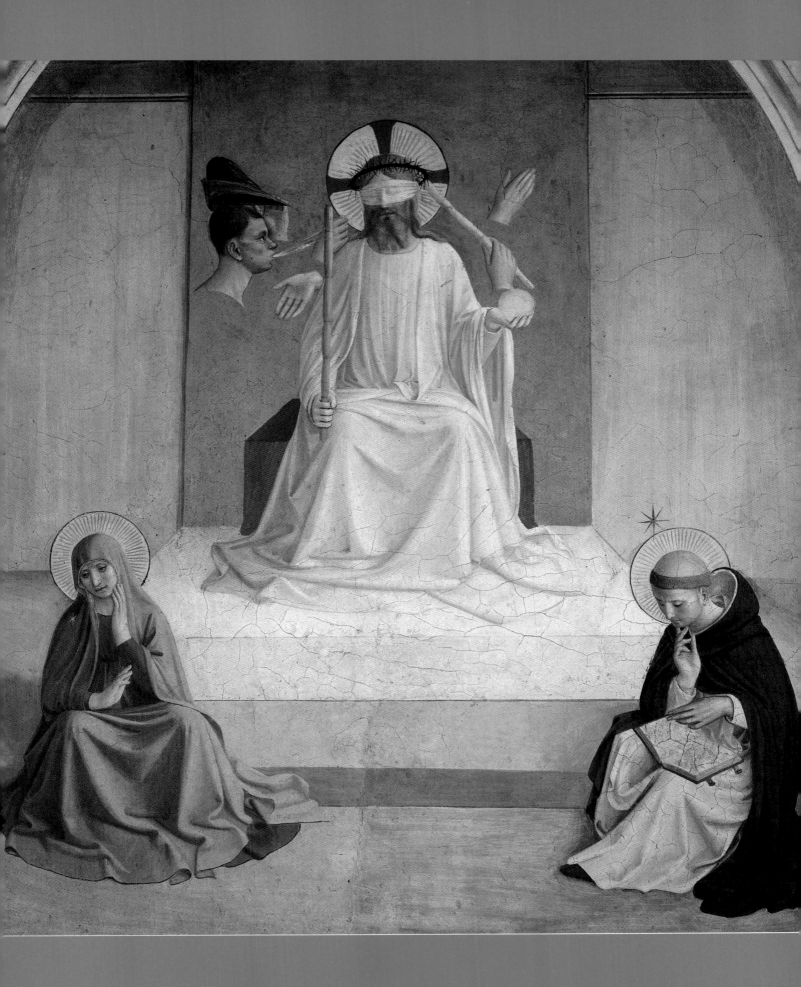

Roman soldiers brought Jesus to Golgotha, the "place called 'The Skull'" (Luke 23:33). Would they have allowed bystanders to approach the condemned man? It is not entirely out of the question. They wound their way through narrow passages, alleyways swarming with pilgrims going about their last-minute preparations for the Feast of the Passover. Some were curious, others moved to pity. Still others mocked or hurled insults.

And there were a few believers—with Mary, never far away.

Giovanni Domenico Tiepolo, *Way of the Cross: Christ Meets his Mother*, 1749.
Church of San Polo, Venice.

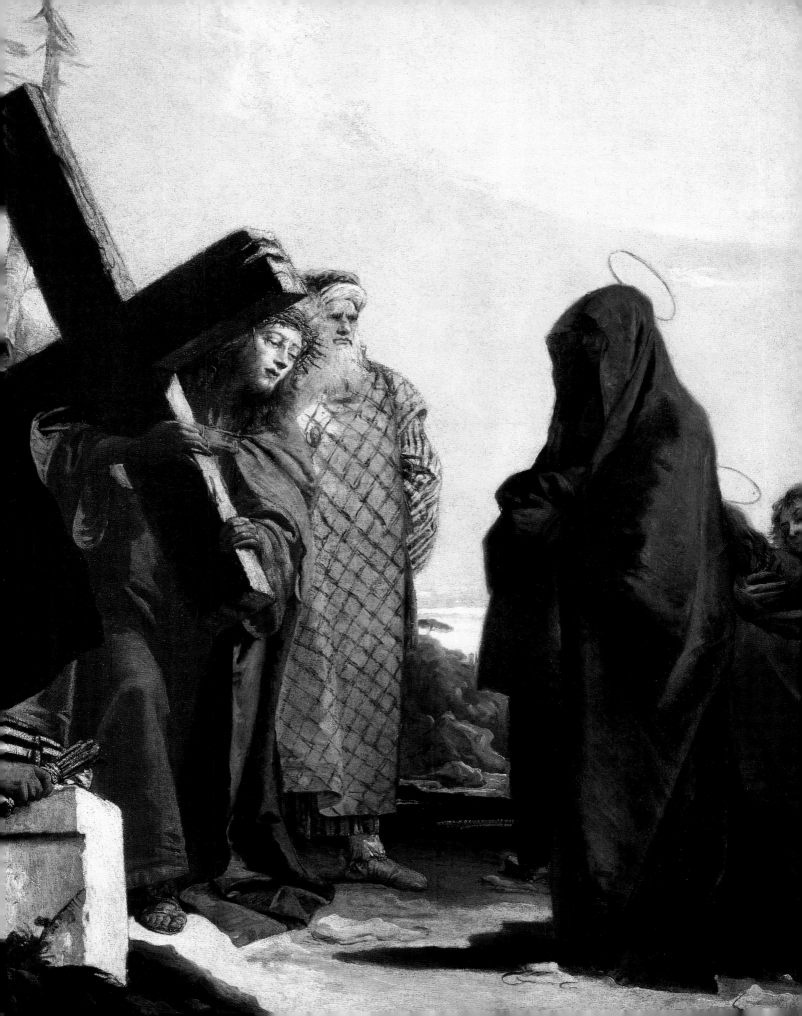

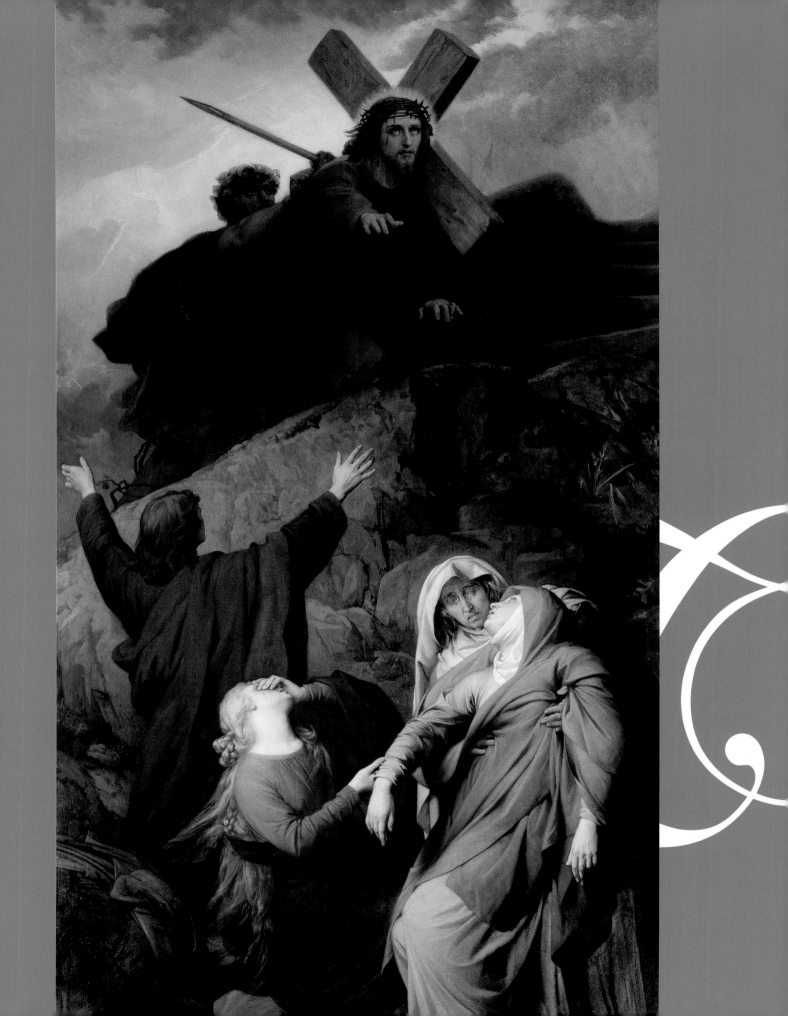

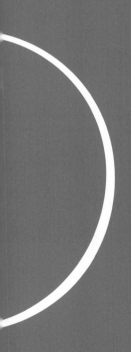

XXXVI MARY'S SUFFERING

Jesus is to die.
Mary swoons.
Silence is called for.

Jules Eugène Lenepveu, *The Virgin at Calvary*, 1861. Musée des Beaux-Arts, Nantes.

Crucifixion represents the most excruciating and ignominious form of torture. Believed to have originated in Persia, it was widely used by the Romans. Cicero regarded it as the most cruel and terrible of punishments. The condemned, often secured by ropes and sometimes—as was Jesus' case—by nails, would die of suffocation and exhaustion. Onlookers and witnesses were made to keep their distance, as is the case with the "holy women" mentioned in the Gospel, who remained loyal to the end while the apostles lay low.

Albrecht Dürer, *The Crucifixion of Christ* (detail), 1495. Gemäldegalerie, Dresden.

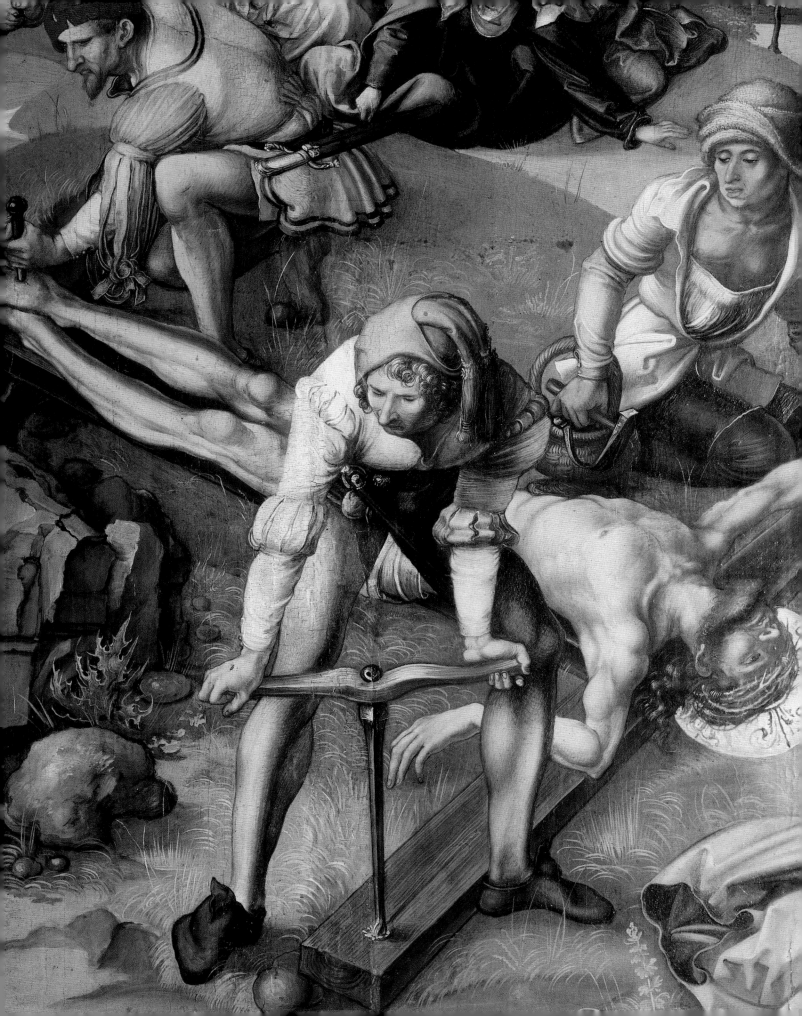

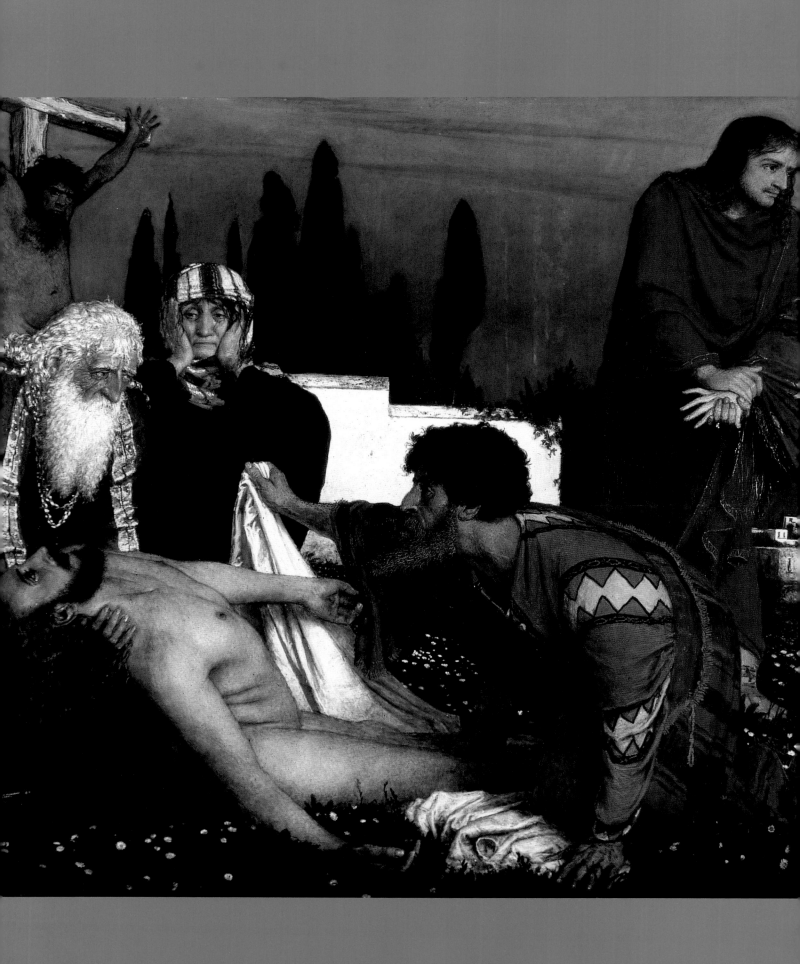

XXXVIII MARY AND JOHN
AT THE FOOT OF THE CROSS

When Jesus died, a man of some importance called Joseph of Arimathea was granted permission by the Romans to take down the body so that it would not be cast into a common grave.

In the background are Mary and John—the man to whom Jesus, in his dying breath, entrusted his mother according to the Gospel of John. "Seeing his mother and the disciple whom he loved standing near her, Jesus said to his mother, 'Woman, this is your son.' Then to the disciple he said, 'This is your mother.' And from that hour the disciple took her into his home" (John 19:26–27). The scene is highly symbolic as John refers to Mary only twice in his Gospel: once at Cana, at the very beginning of Jesus' mission, and here during the Crucifixion. As at Cana, Mary also stands for Israel, whose legacy will fall to Jesus' disciples. They are to take this legacy to dwell with them—as the Evangelist said of Mary—and to use it as their constant source of inspiration.

Arnold Böcklin, *Lamentation* (detail), 1876.
SMPK, Nationalgalerie, Berlin.

The Pietà: a representation of Mary, fully spent by her suffering and tears, holding her son's body. This image proliferated during the Middle Ages with its fascination with death's devastation. "The lance which opened His side," wrote Saint Bernard, "passed through the soul of the Blessed Virgin, which could never leave her Son's Heart." The Pietà in its various manifestations continues to inspire artists today.

Michelangelo, *Pietà*, 1498–99. Saint Peter's Basilica, Rome.
Following pages: Enguerrand Charonton, *Pietà of Villeneuve-lès-Avignon*, 1460. Musée du Louvre, Paris.

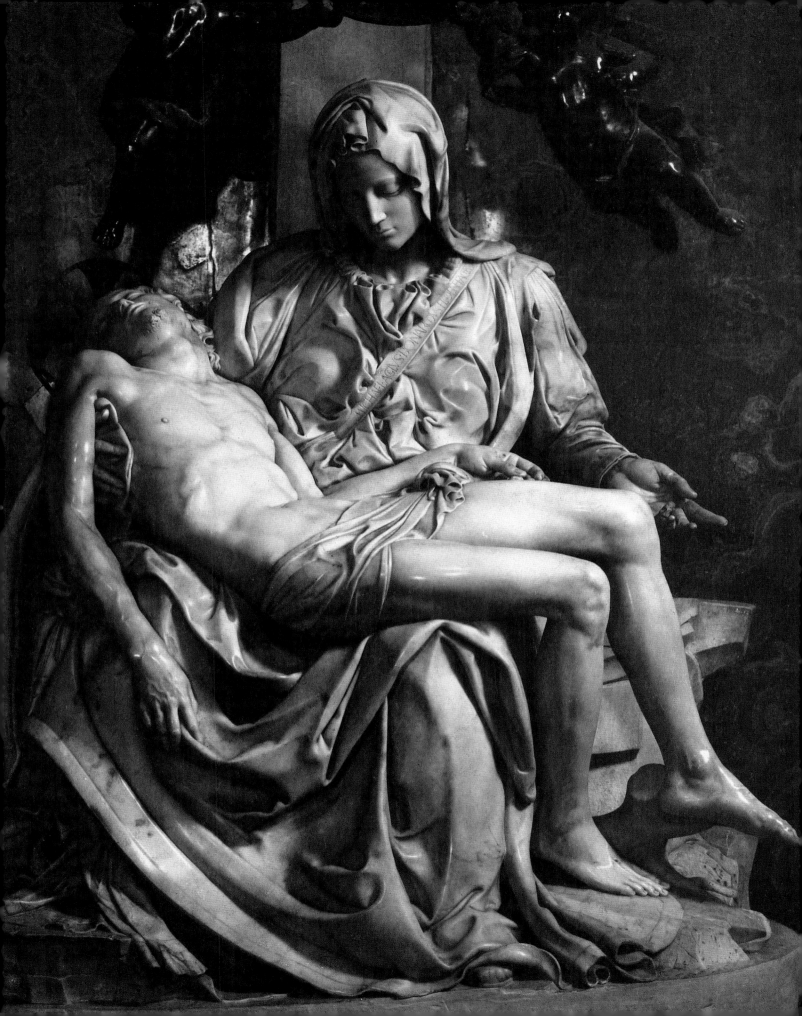

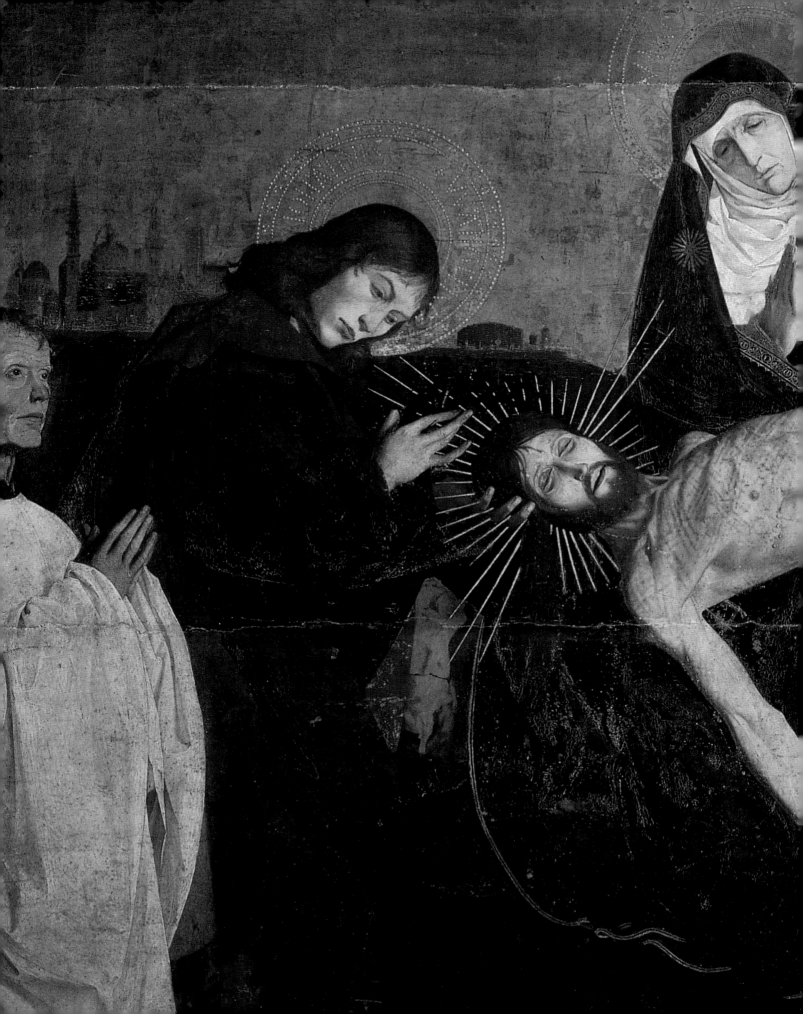

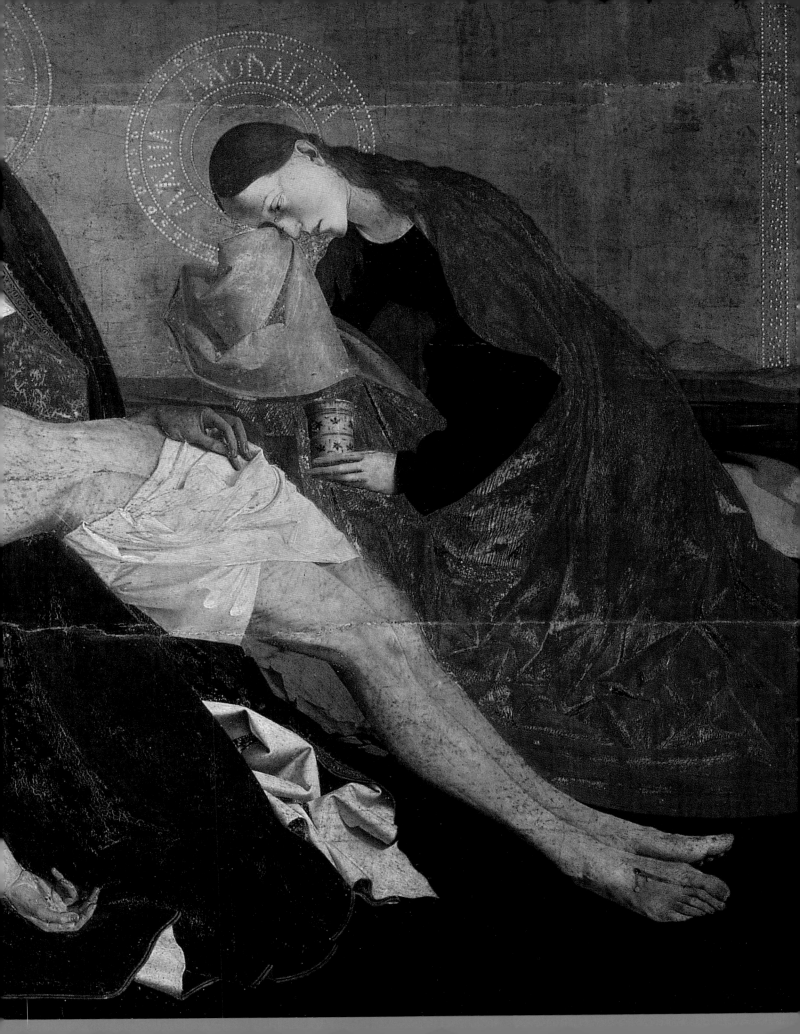

According to Luke, this took place not far from Jerusalem. Jesus led his companions into the countryside, blessed them, and "as he blessed them, he withdrew from them and was carried up to heaven" (Luke 24:50–52).

Was Mary there? It is possible, as Luke tells us in the Acts of the Apostles, that they gathered to pray in Jerusalem after the Ascension, "together with some women, including Mary the mother of Jesus, and with his brothers" (Acts 1:14).

Andrea Mantegna, *The Ascension of Christ*, 1464. Galleria degli Uffizi, Florence.

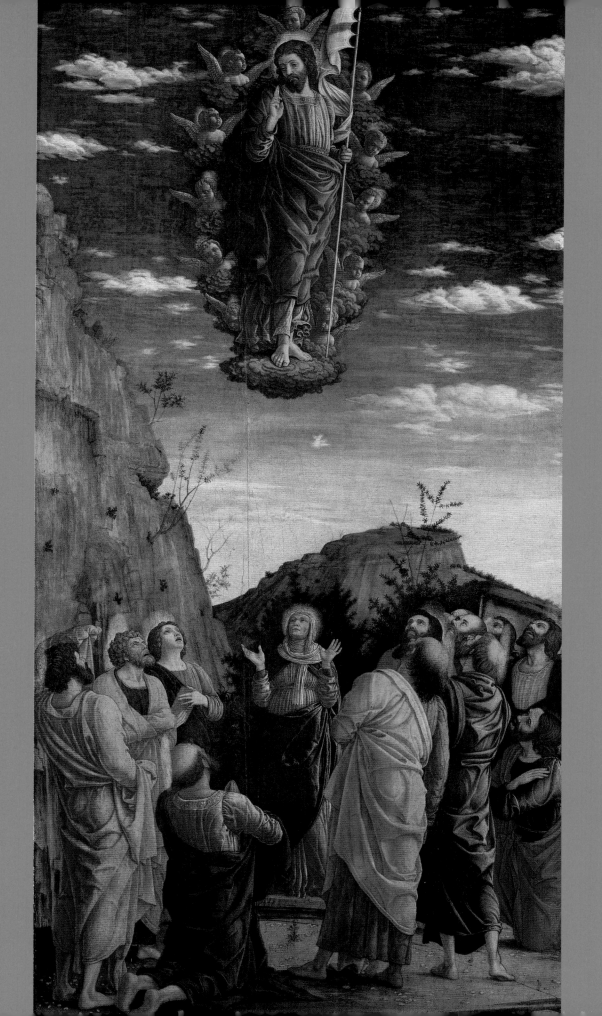

Moretto da Brescia, *The Coronation of the Virgin* (detail), 1530. Private collection.

A Holy Woman

In the fifth century, the mother of Christ was proclaimed
"Mother of God" or "Theotokos" in Greek. Throngs of people
in the East acclaimed her "the Theotokos." Yet religious figures,
theologians, and believers sought to know still more about her.

Did the "Theotokos" die? What was her place in heaven?
Could the body that bore Jesus have been "reduced to dust?"
Debates and questions have lasted for centuries—as has faith.

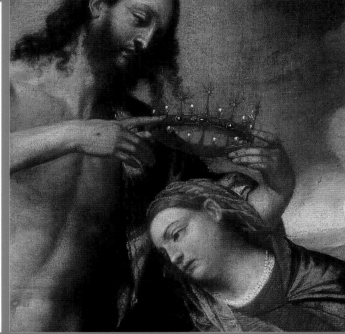

XLII THE DORMITION

During the Middle Ages the idea emerged that Mary, untainted by original sin, had also been spared death and therefore simply fell into slumber, although no mention of this is made in the New Testament.

This gave rise to the tradition known as "Mary's Dormition"—as such, Mary was accorded a grace that even Jesus had been denied. Was she dead or merely sleeping? This tradition was the subject of debate up until the Second Vatican Council, in the mid-twentieth century. In 1997, Pope John Paul II settled the matter by acknowledging the "existence of a common tradition that sees the death of Mary as her introduction to celestial glory."

Caravaggio, *The Death of the Virgin* (detail), 1601–06. Musée du Louvre, Paris.

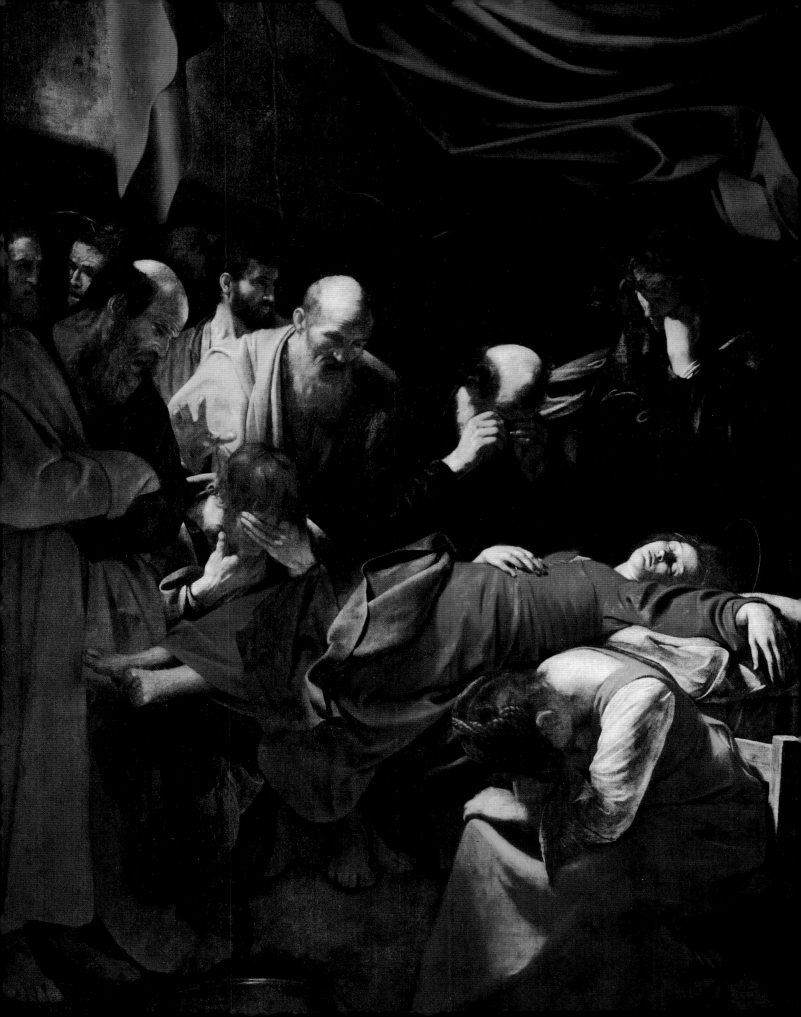

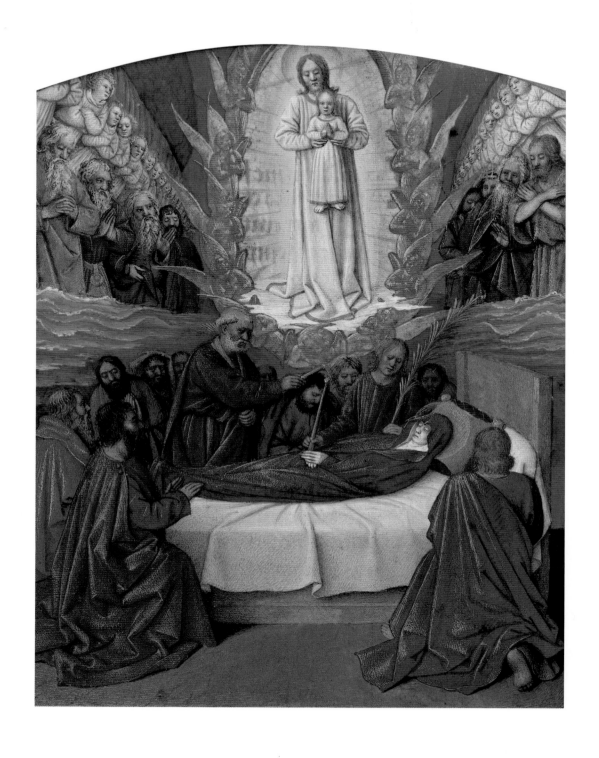

Jean Fouquet, *Death of the Virgin*, 1455. Musée Condé, Chantilly.
Facing page: Jean Fouquet, *Funeral of the Virgin*, 1455. Musée Condé, Chantilly.

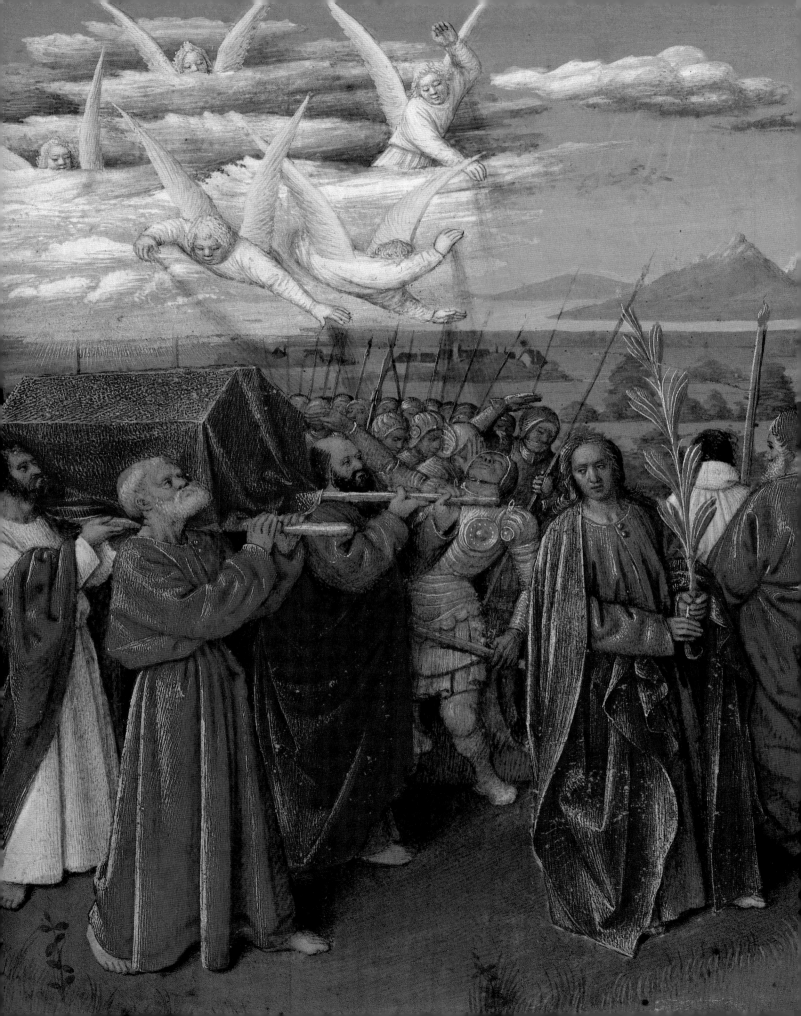

XLIII THE ASSUMPTION

Toward the end of the fifth century, various texts recounting the death of Mary began to circulate in the East. According to some, her body was placed in a tomb but remained as radiant and undefiled as ever. Others maintained that it was borne to heaven by Jesus himself. This "Assumption" is celebrated on August 15. In the nineteenth century, many petitions were addressed to the Vatican asking that the pope make this dogma, declaring it as an act of faith. Pope Pius XII acquiesced in 1950, after consultations with the world's bishops, saying that "Mary was taken up body and soul into celestial glory"—something that painters had decided long before him.

Nicolas Poussin, *The Assumption of the Virgin*, 1649–50. Musée du Louvre, Paris.

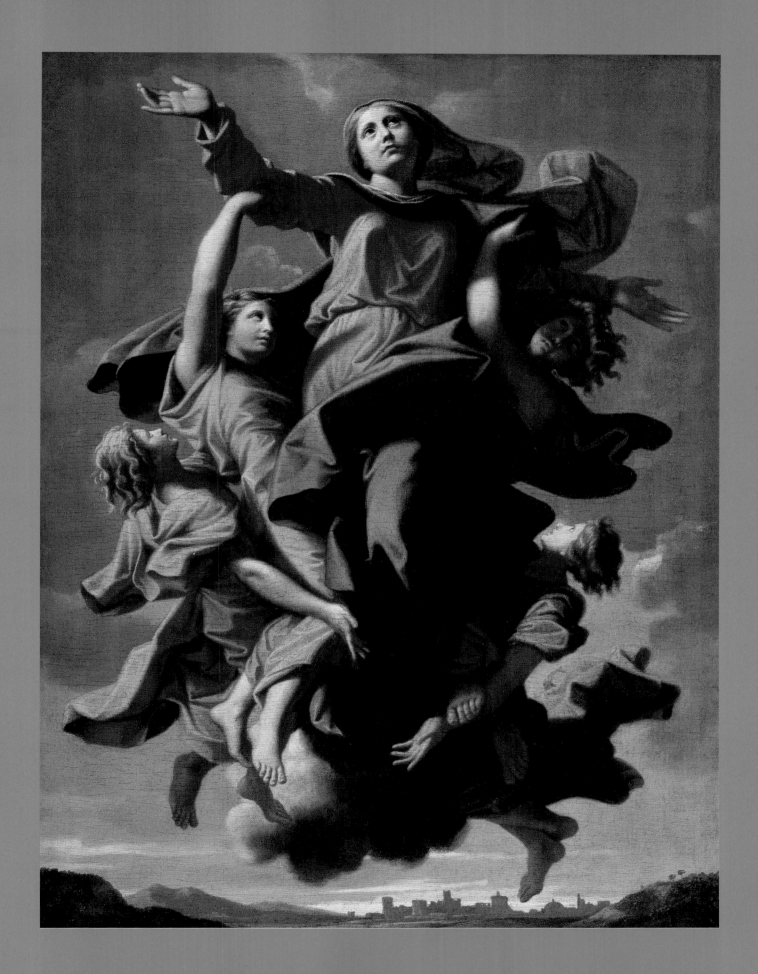

Worship of Mary as "queen of Heaven" began in the East in the first centuries. Byzantine artists depicted her attired in the same way as the empress. Their masterful mosaic-work shows her being crowned by her son (p. 141). At the Council of Ephesus, where the role of Mary was hotly debated, Cyril of Alexandria came up with the winning arguments, declaring in prayer: "We salute you, O Mary, Mother of God, treasure of the universe, inextinguishable flame, crown of virginity, scepter of the true Faith, indestructible temple, tabernacle of the One Whom the world cannot contain, and Mother and Virgin. In your virginal womb you enclosed the Immense and Incomprehensible One."

The coronation of the Virgin by her Son or by God, reuniting Father and Son, was to inspire masterpieces by the greatest painters. During the Middle Ages, the French trouvère poet, Rutebeuf, called her: "My holy beauteous Queen, glorious Virgin, Lady full of grace."

At that time in particular, Mary was exalted to the extent that some commentators wondered if she wasn't being made a fourth member of the Trinity.

Jan van Eyck, *Mary, Queen of Heaven* (detail), 1390–1411. Cathedral of Saint Bavon, Ghent.
Following pages, left: Veronese, *Coronation of the Virgin* (detail), 1555.
Church of San Sebastiano (sacristy), Venice.
Following pages, right: *Coronation of Mary*, 1290. Basilica of Santa Maria Maggiore, Rome.

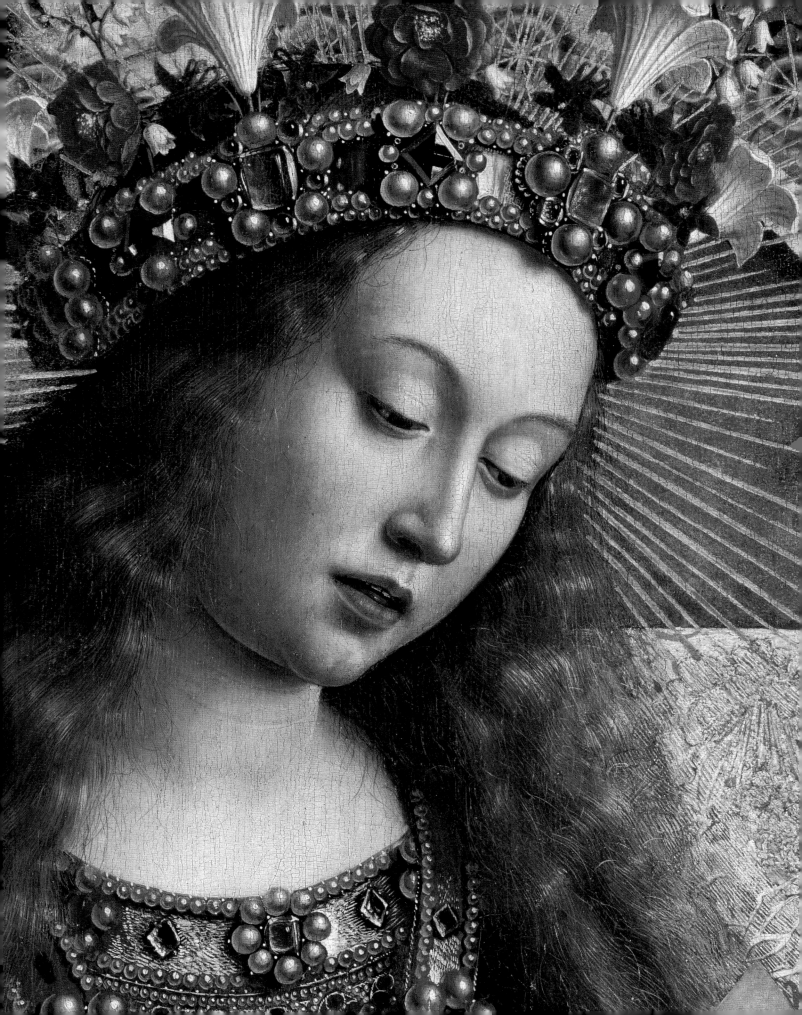

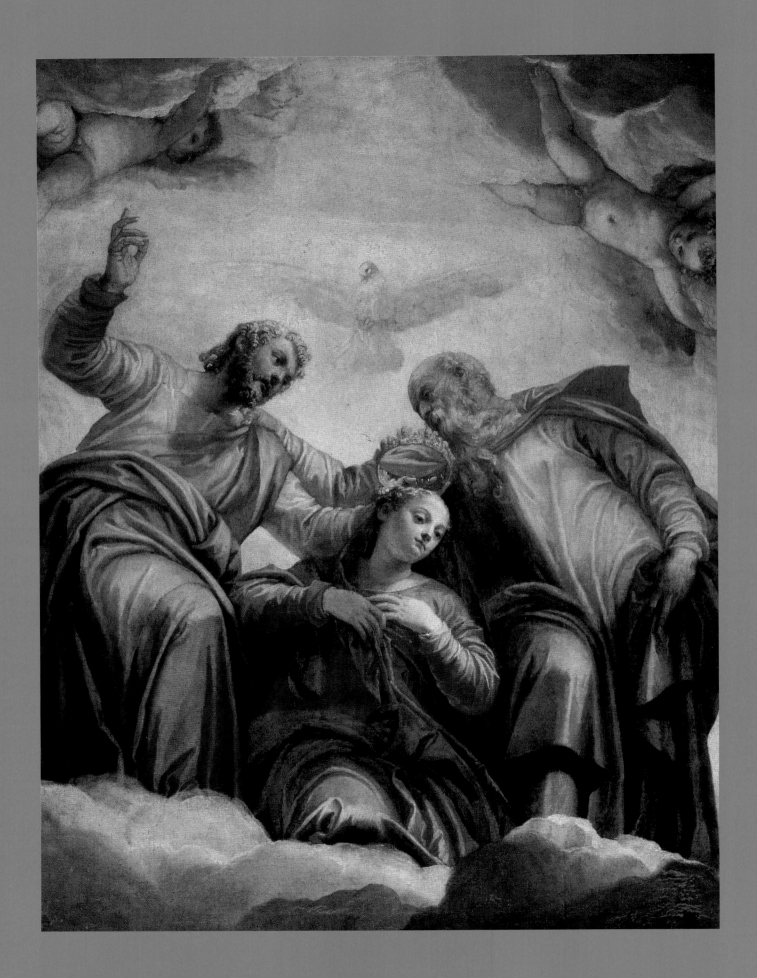

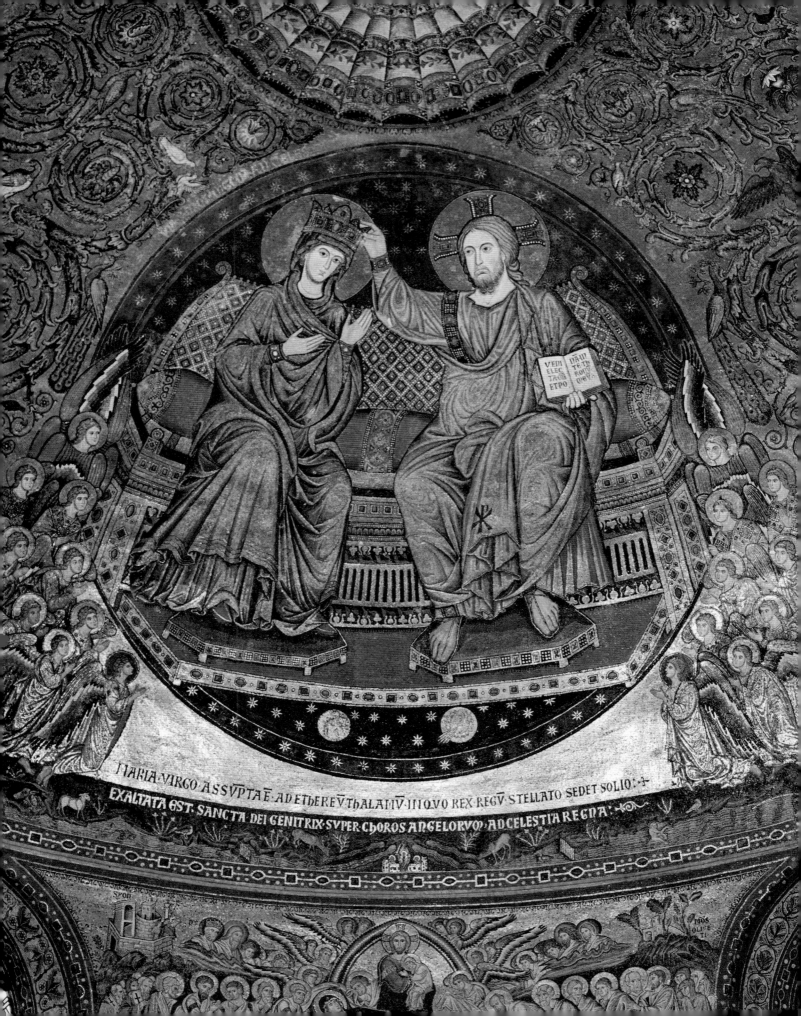

VENI ELECTA MEA ET PONA

IN TE THRONUM MEUM

MARIA VIRGO ASSVPTA E AD ETHEREV THALAMV INQVO REX REGV STELLATO SEDET SOLIO

EXALTATA EST SANCTA DEI GENITRIX SVPER CHOROS ANGELORVM AD CELESTIA REGNA

XLV JUDGMENT DAY

At the start of the second millennium, Mary was increasingly seen as the one who intercedes for "sinners, now and at the hour of our death."

This altarpiece is perhaps the best illustration of the exceptional importance attached to Mary during the Middle Ages. She is in the middle, crowned by the Father and the Son, with the Holy Spirit in the shape of a dove above her head—it is indeed as if she were a fourth member of the Trinity. To the left and right are the chosen few, virtually all of whom are religious figures. The earth occupies the bottom portion, linked to heaven by a small crucifix. Below the earth are hell and purgatory, from which a few souls to the left ascend to Mary like small flames. An angel helps to extract one of them from agony—tradition has it that it is the soul of a pope.

Enguerrand Charonton, *The Coronation of the Virgin* (detail), 1454.
Musée Pierre de Luxembourg, Villeneuve-lès-Avignon.

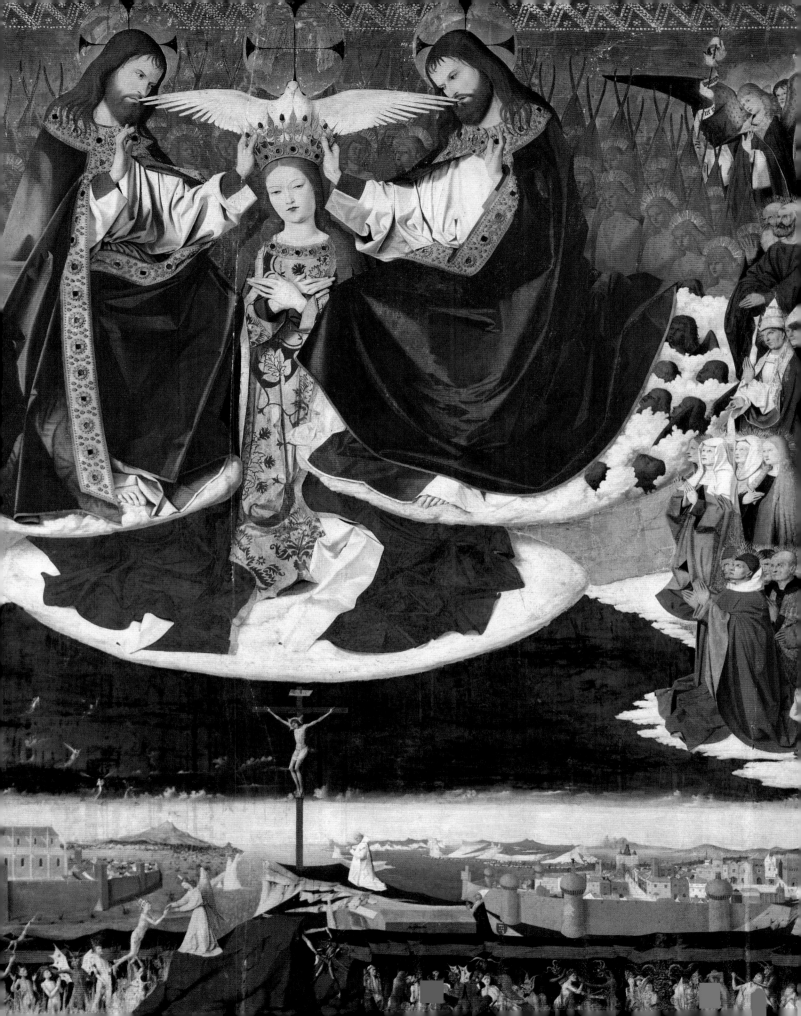

XLVI MARY: INTERCESSOR AT THE LAST JUDGMENT

The notion of purgatory was not defined until the Middle Ages: a place where sinners were purified through a period of hardships before being admitted to God's grace. The living were therefore solicited to pray for their dead to make this period of hardship as short as possible. Their natural reaction was to beseech Mary to intercede for the deceased. Thus she became the lawyer par excellence at what became known as the "judgment seat of God."

Catholic Church leaders prefer to see this as intercession or mediation on Mary's part. She should be requested to "pray for us" rather than to "grant our prayer" since she is not on a par with God. Yet the faithful believe that her prayer will receive privileged attention.

Some believe that Jesus can refuse his mother nothing. In many paintings they are shown together, high above the clouds and humankind.

Tintoretto, *Paradise* (detail), 1588–92. Doges' Palace, Venice.

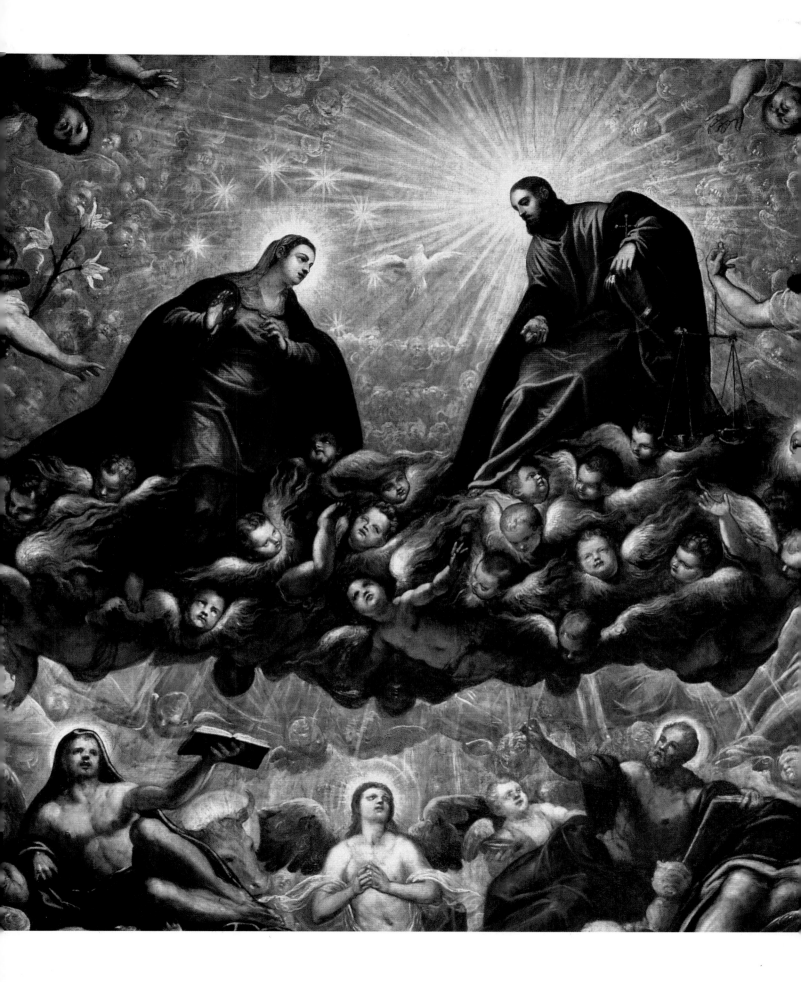

Sandro Botticelli, *Madonna and Child with Six Angels* or *Madonna of the Pomegranate* (detail), 1487.
Galleria degli Uffizi, Florence.

Mary of a Thousand Faces

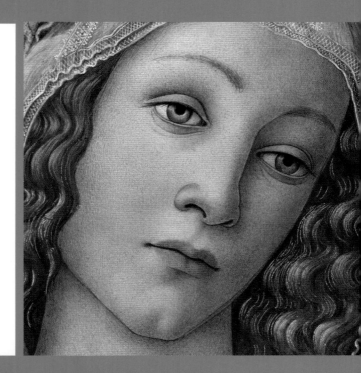

Madonna, Maria, Blessed Virgin, Our Lady of the Seven Sorrows, Queen of Heaven, the patron of dozens of cathedrals and hundreds of villages, Mother of God, or simply Mary—she is prayed to and admired worldwide. Christ's mother is almost as beloved as God himself, since she can be everything to everybody. She is Mary of a thousand faces.

"As a lily among the thistles,
so is my beloved among girls" (Song 2:2).
 This verse from the Song of Songs is often applied to Mary. For many of the faithful,
she is first and foremost a maiden, embodying innocence, faith in the future, and beauty.

Pierre Paul Prud'hon, *Portrait of Mary as a Girl* (detail), 1811. Pushkin Museum, Moscow.

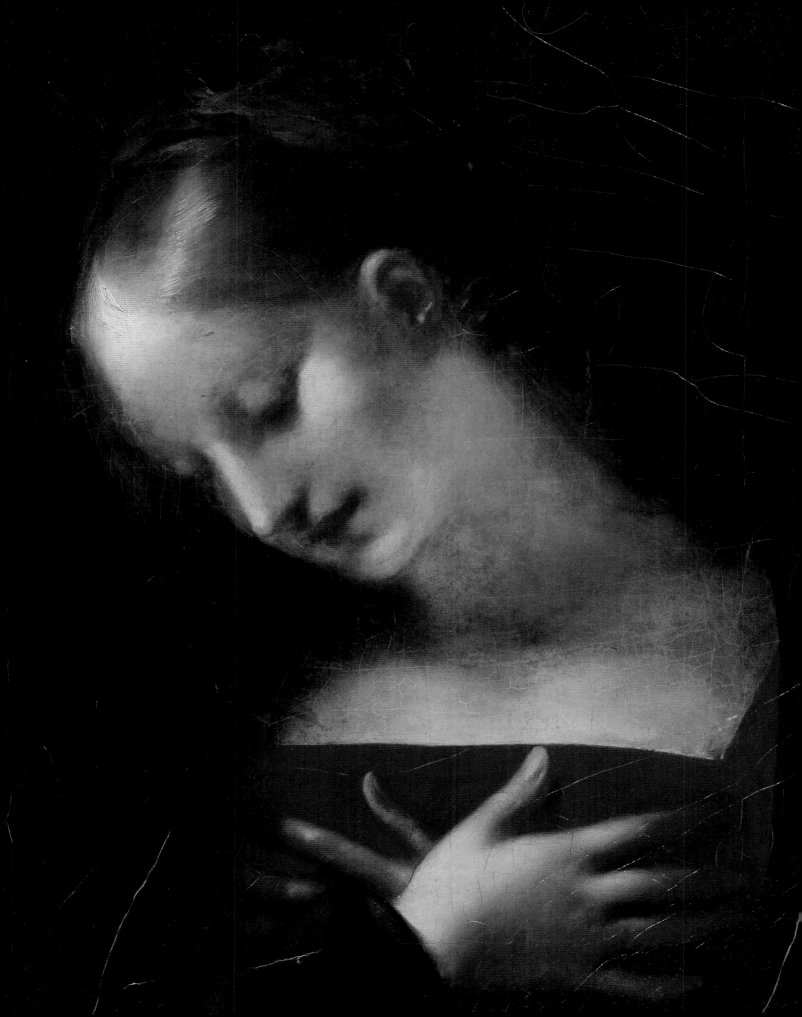

XLVIII EVERYDAY WORSHIP

Ordinary religious devotion has not always engendered masterpieces. But these images have inspired surging sentiments of fervor, tenderness, emotion, and indeed prayers.

Anonymous, *Virgin with Infant Jesus* (detail), 1937.
Archiv für Kunst und Geschichte, Berlin.

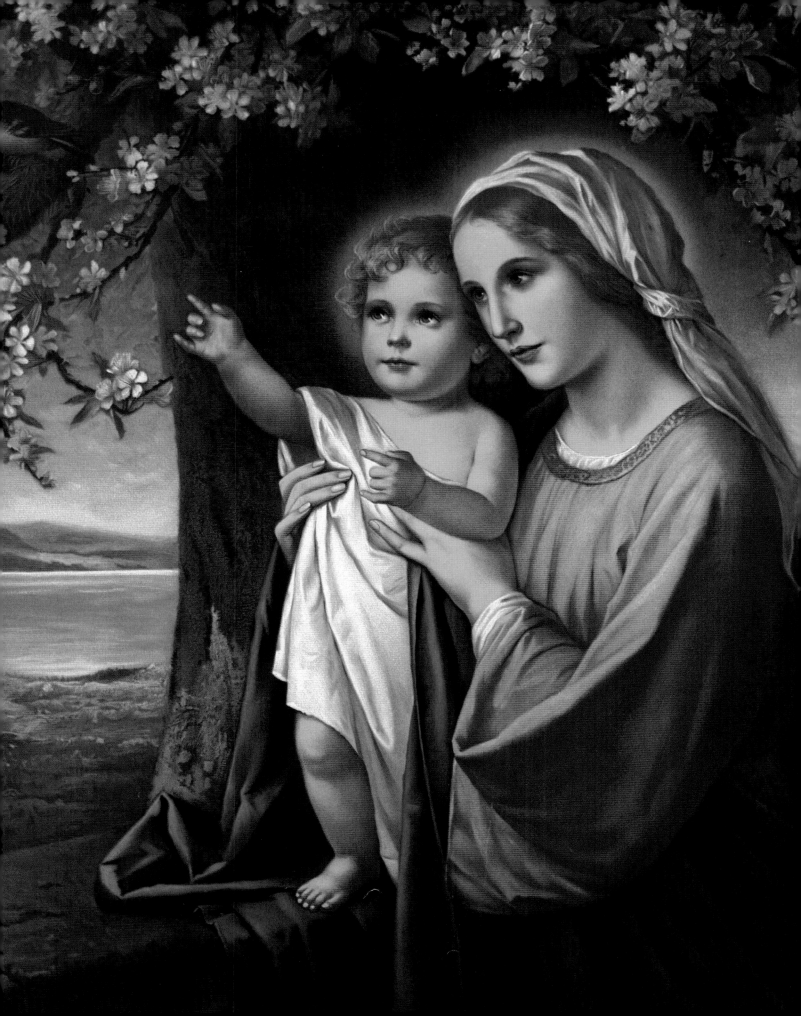

Another of Mary's faces—that of a mother who has lost her
child—has endeared her to so many women who have
experienced the same heartbreak, particularly from the Middle
Ages onward. The "Stabat mater dolorosa" ("At the Cross her
station keeping, stood the mournful Mother"), attributed to
Italian poet Jacopone da Todi, emerged in the twelfth century
and was to be a source of inspiration for the greatest composers.
Saint Bernard wrote: "Mary was a martyr, not by the sword
of the executioner, but by the bitter sorrow of heart."

Rosso Fiorentino, *Pietà*, 1530–40. Musée du Louvre, Paris.

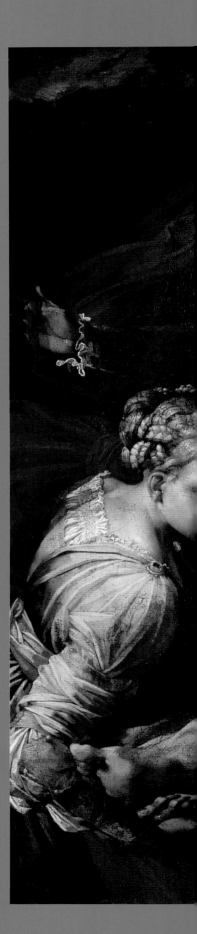

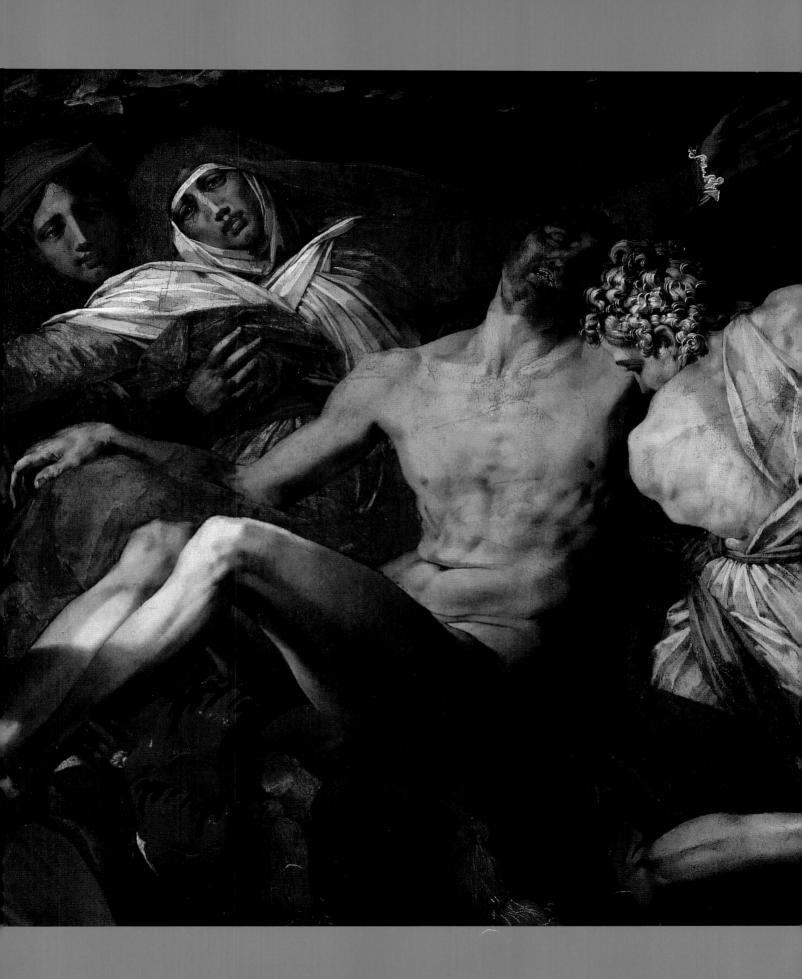

L MARY, THE PROTECTOR

A mother is also the protector of her children. A fragment of papyrus dating to the late third or early fourth century bearing an inscription in Greek has been found—it is perhaps the first Marian prayer ("the Sub Tuum"). It reads: "We fly to thy patronage, O holy Mother of God; Despise not our petitions in our necessities, but deliver us always from all dangers." The same entreaty fuels our prayers even today.

Representations of the Virgin protecting the poor, children, and sinners in the folds of her great imperial mantle were increasingly common from the fifth century, becoming particularly popular in the nineteenth century. The image on the facing page shows nuns and monks. In the nineteenth century, the Marian devotion enjoyed an extraordinary boom, with no less than 149 congregations dedicated to Mary in France alone. This exceeds the number of those dedicated to Christ himself.

Over the centuries, Mary has taken up abode on church porches, on stained-glass windows, as well as on roadsides and waysides, and in tiny recesses above doors. She stands wherever her protection—against war and famine, plague and evil—is invoked.

Notre-Dame de Bon Secours, 1829–37.
Musée National des Arts et Traditions Populaires, Paris.

NOTRE-DAME DE BON SECOURS.

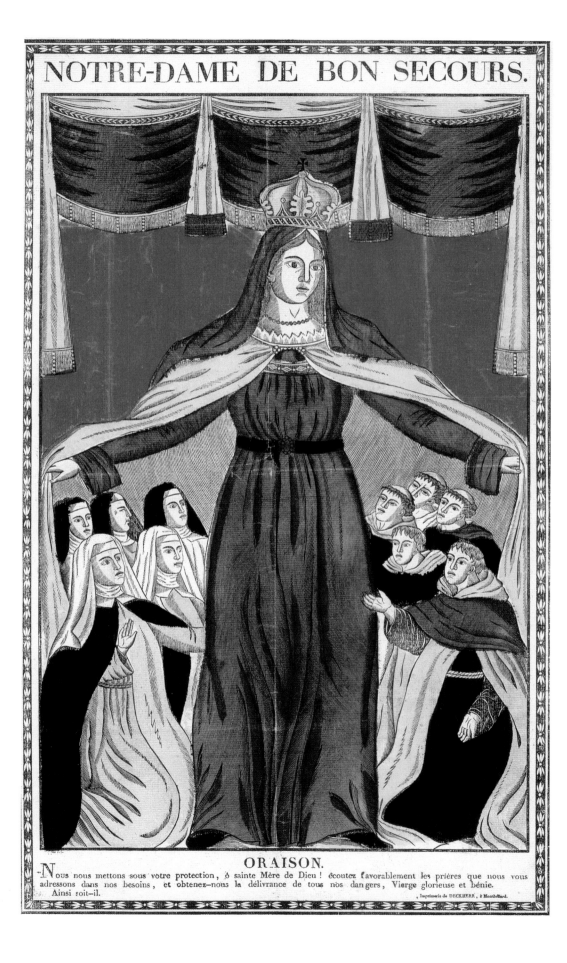

ORAISON.

Nous nous mettons sous votre protection, ô sainte Mère de Dieu ! écoutez favorablement les prières que nous vous adressons dans nos besoins, et obtenez-nous la délivrance de tous nos dangers, Vierge glorieuse et bénie. Ainsi soit-il.

Imprimerie de DECKHERR, à Montbéliard.

Heads of Catholic States often place their countries under Mary's protection. In 1638, King Louis XIII of France addressed her publicly in a solemn vow to "take such pains to defend this kingdom from the designs of its enemies, whether in the curse of war or the sweetness of peace." The three-hundredth anniversary of this consecration of France by the Virgin was celebrated in 1938—the fact that war was in the air added gusto to the proceedings. Furthermore, on May 19, 1940, just nine days after the triumphant debut of the German offensive against France, the secular government of the Third Republic held Mass in the Cathedral of Paris to invoke the protection of "Notre-Dame."

Jean Auguste Dominique Ingres, *Vow of Louis XIII* (detail), 1824. Cathedral of Notre-Dame, Montauban.

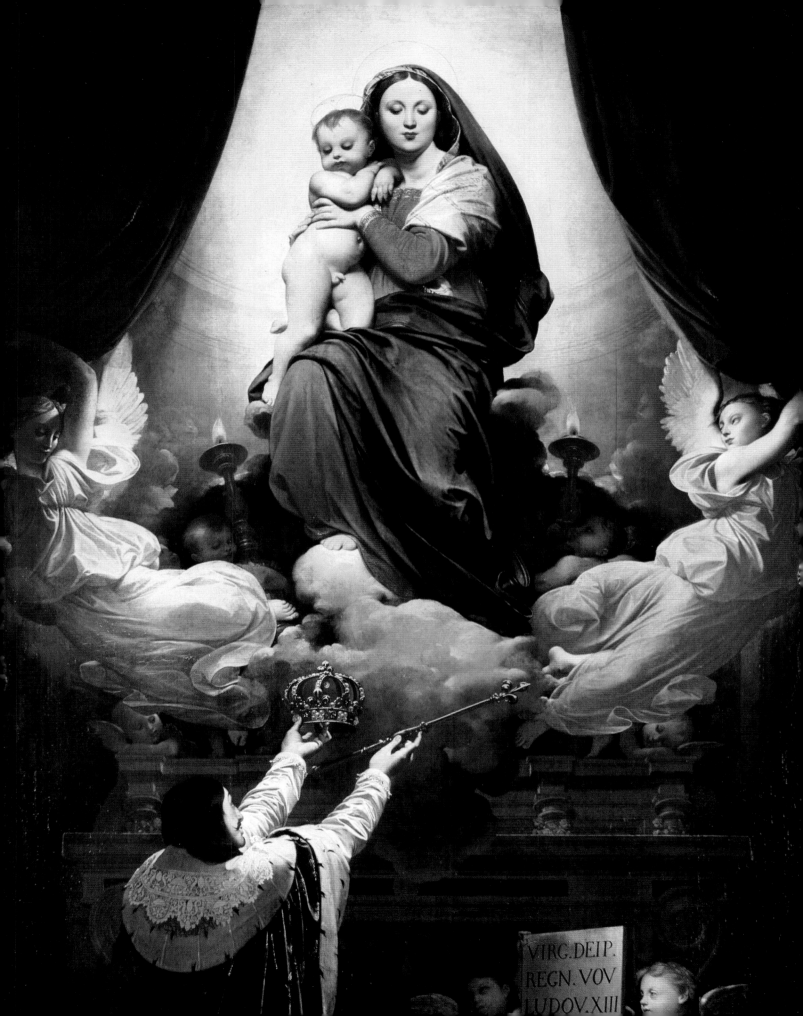

VIRG.DEIP.
REGN.VOV
LUDOV.XIII

LII MATERNAL BLISS

For millions of women, Mary is first and foremost a mother like any other. She has shared in their troubles, their joys, their concern about their child's future, and their simple pleasures.

I have nothing to offer, nothing to ask.
Mother, I have come only to see you.
Because you are beautiful.

Paul Claudel, "The Virgin at Noon," *Poetry Magazine* 87 (December 1955): 130.

Raphael, *Madonna dell Granduca* (detail), 1504–05. Galleria Palatina, Palazzo Pitti, Florence.

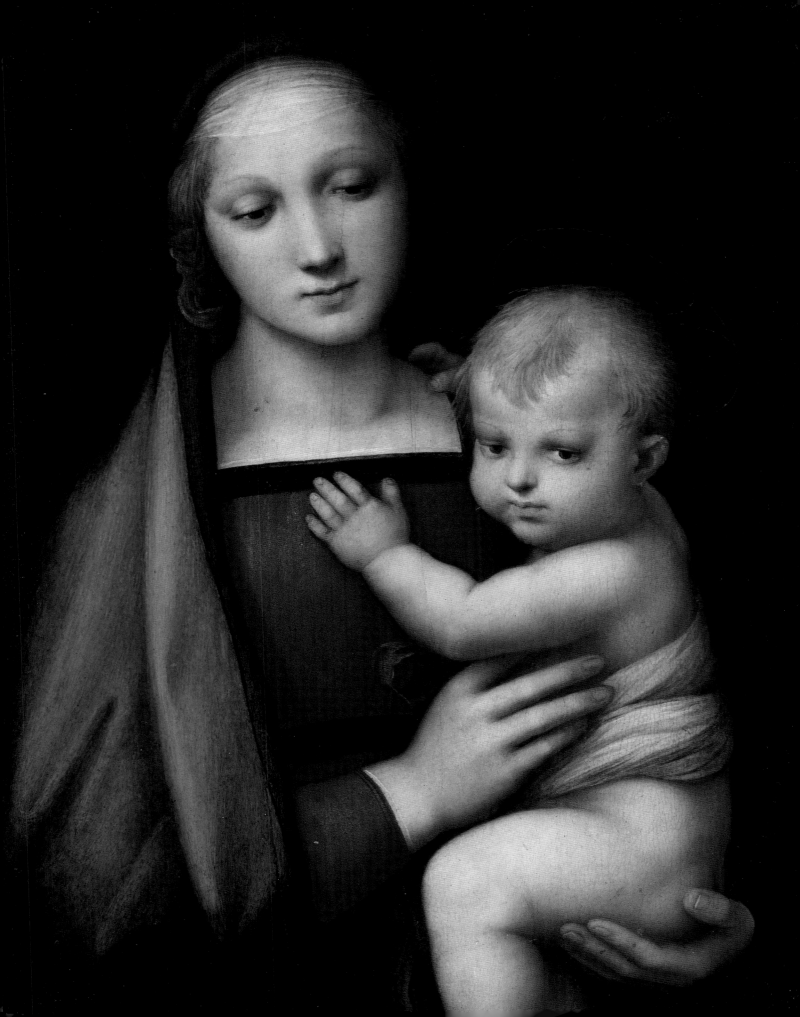

Translated from the French by Susan Schneider
Copyediting: Christine Schultz-Touge
Iconographical consultant: Renaud Temperini
Iconographical research: Nadia Zagaroli
Design: jeanyvesverdu
Typesetting: Claude-Olivier Four
Proofreading: Penelope Isaac
Production: Corinne Trovarelli
Color separation: Dupont Photogravure

Distributed in North America by Rizzoli International Publications, Inc.

Originally published in French as *Une femme nommée Marie*
© Éditions Flammarion, Paris, 2005

English-language edition
© Éditions Flammarion, 2006

87, quai Panhard et Levassor
75647 Paris Cedex 13

www.editions.flammarion.com

06 07 08 4 3 2 1
FC0526-06-IX
ISBN-10: 2-0803-0526-3
ISBN-13: 9782080305268
Dépôt légal: 09/2006

Printed in Italy by Canale